Romanesque Art

NORBERT WOLF

TASCHEN

HONG KONG KÖLN LONDON LOS ANGELES MADRID PARIS TOKYO

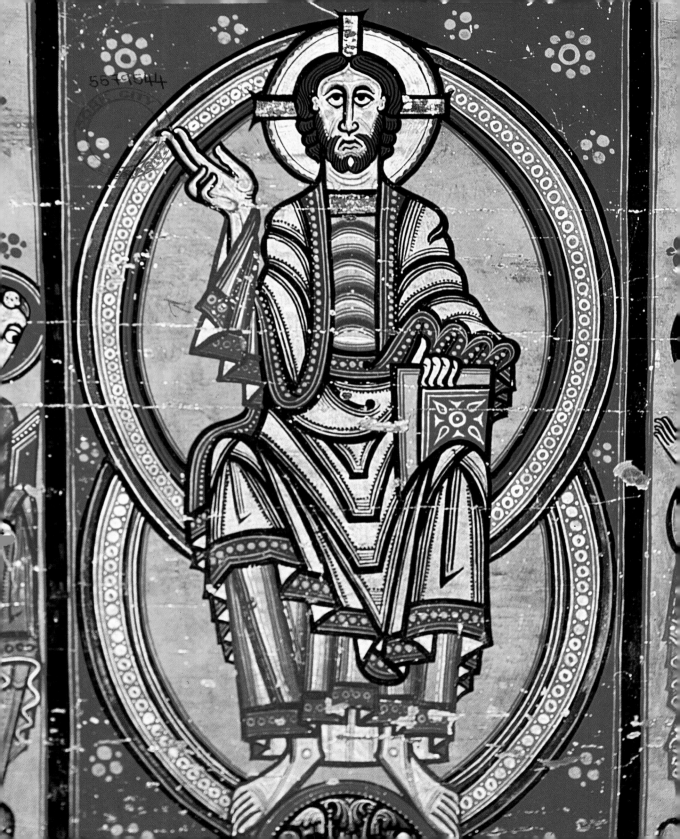

contents

ᴛʜe ᴇmᴇʀgence of western ᴀʀt

Giorgio Vasari's "Lives" of the leading Renaissance architects, sculptors and painters, written in the mid-sixteenth century, contain an outline of developments in the arts. Yet no mention is made of "Romanesque" art. Vasari and his readership neither knew this term, nor was he in a position to define the style, although he did make a rudimentary attempt.

Vasari was a spokesman for his period, that late Renaissance for which classical antiquity was the supreme model and medieval art was an aberration. The author laments that in the battle against the heathens, the early Christians unfortunately destroyed the incomparable art of the ancients and replaced it by abominations. All sense of beautiful form was lost. The barbarians who inundated the Roman Empire in the migration of nations had produced only "jumping jacks" as artists and "crudities" as works, asserted Vasari, things that must needs appear ridiculous to the cultivated men of his era.

Especially medieval architecture, lamented Vasari, adhered to a style "we nowadays describe as the Germanic". The greatest ugliness produced by this impudently anticlassical manner was Gothic. Occasionally, however, a dim light could be made out at the end of the tunnel of the Middle Ages. Being a Tuscan and a eulogist of his homeland, Vasari descried a shimmer of better things to come in the church of S. Miniato al Monte in Florence (ill. p. 7), in the cathedral and bap- tistry in Pisa (ill. p. 8), or in S. Martino cathedral in Lucca – buildings now classified as belonging to the Romanesque period in the history of art.

"La première définition de l'occident" ("ᴛʜe ꜰɪʀst definition of the western world", ʜenri ꜰocillon)

The round arches of Romanesque churches as opposed to the pointed arches of Gothic cathedrals, the use of the "ancient" material of marble in the examples mentioned, their spacious wall surfaces, unachievable in Gothic "skeleton construction", which could be covered as in ancient architecture with frescoes and mosaics – all of these seemed a distant echo of ancient Roman building and appeared at least to adumbrate that perfection of art with which the Renaissance brought about a rebirth of antiquity. When art historians began to discover the Romanesque as a style in the early nineteenth century, Vasari's polarization still reverberated: in the derivation of the term from "Roman" as well as in the touch of inferiority that initially attached to the style when its columns, round arches, barrel and groined vaults (which had once more become the focus of attention) were judged to be derivative and corrupted classical forms.

910 — Founding of monastery in Cluny **972 — Founding of Cairo University** **972 — Future Emperor Otto II weds Byzantine Princess Theophanu** **987 — In France, the Carolingian dynasty becomes extinct and Hugo Capet is crowned king**

"Then, in the year 1013, during the reconstruction of the wonderful church of San Miniato al Monte … one saw art regain some of its force again. For apart from the marble adornments visible inside and out, one recognized on the main façade that the Tuscan architects … tried their best to imitate the good antique order …"

Giorgio Vasari, 1568

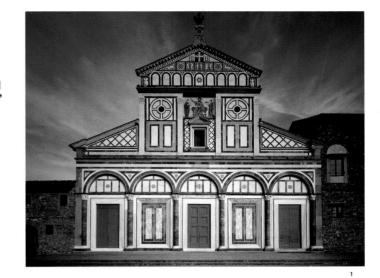

1. FLORENCE, SAN MINIATO AL MONTE (WEST FAÇADE)

Eleventh to thirteenth century

The term "Romanesque architecture" was used as early as 1819 by William Gunn, an Englishman. But it was not until the 1830s, when the French architectural historian Arcisse de Caumont described the architecture of the Middle Ages, from the fifth to the thirteenth century, as "roman", implying its derivation, if a quite primitive one, from the ancient Roman art of building, that the term "Romanesque" became accepted as the name of a period and gradually shed its negative connotations. Romanesque advanced to become a concept with whose aid the art of the eleventh and twelfth centuries could be defined as a consistent whole and distinguished from the Gothic. Today, Romanesque stands alongside Gothic, Renaissance, and Baroque as one of the four great phases of Western culture.

The term Romanesque, as now generally defined, covers various early-medieval approaches which found an independent, compelling, and often monumental language in every field of art. Or, as the French art historian Henri Focillon (1881–1943) said, "With the Romanesque, the Western World defined itself for the first time".

As widely accepted as this statement has become, opinions on when this self-definition began and how long it lasted still differ considerably. In other words, the chronology of Romanesque art remains extremely controversial in the literature. It is difficult to state the precise dates at which the period began and ended. These varied from country to country. With regard to the German-speaking countries that then formed the Holy Roman Empire, the general placement of the emergence of Romanesque art around the year 1000 runs counter to another stylistic category – Ottonian art.

In many respects, Ottonian art was a continuation of Carolingian. The cultural life of the Carolingian period was marked by the claim of Charlemagne (742–814), developed in rivalry with Byzantium, to a "renovatio", or renewal, of the Roman Empire. In art this culminated in an effort to link up with the late antique and early Christian phase in Italy. Nowhere was this attempt more clear than in the marvellous manuscript illumination and ivory carvings of the late eighth and ninth centuries. The surviving murals, mosaics, fragments of stained glass, and wonderful specimens of goldsmith's work and church treasuries, add up to a colorful and exquisite picture of the artistic skills of the day – even though we should recall that these were limited to monasteries and a few urban centers in a Europe otherwise dominated by wilderness and a heathen environment. The subsequent period of political reorganization of the empire under the Saxon monarchs is referred to by German art historians as the Ottonian (919–1024). Here the cultural focus now lay in the hereditary imperial land of Saxony, including Magdeburg and Hildesheim. Yet Cologne, Essen, Fulda, Trier, Regensburg, Salzburg, and the Reichenau region

994 — Montecassino is destroyed by the Saracens

996 — Cane sugar comes from Alexandria to Venice

1001 — Stephan the Holy of Hungary receives title of Apostolic King from the pope

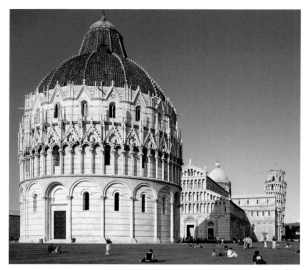

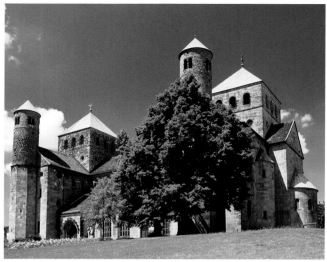

<div style="text-align: right">2</div>

<div style="text-align: right">3</div>

also played an outstanding role, especially due to the influx of Byzantine ideas that made itself felt there. In addition to masterpieces of ecclesiastical architecture such as St. Michael's in Hildesheim (ill. p. 8), and St. Pantaleon's in Cologne, a self-confident art of sculpture developed. Foremost among the increasingly large-scale ritual images was the *Gero Cross* in Cologne Cathedral, carved between 970 and 976 (ill. p. 9). The physical presence of the over-lifesize Christ anticipates the monumentality of later Romanesque crucifixes, even though the former gilding on the wood of the cross still reflected more venerable conceptions of ecclesiastical art treasures.

In the early eleventh-century Hildesheim Door, the German Ottonian produced a masterwork of bronze casting (ill. p. 10). Ivory carvings, reliquaries, book bindings, antependia (altar screens), and not least the German Imperial Crown now in the Vienna Treasury, attest to the artistic accomplishments of that era. Yet the most impressive branch of Ottonian art was surely book illumination, represented especially by the exorbitant liturgical manuscripts produced in Reichenau around the year 1000. St. George's in Oberzell, Reichenau, harbors an eloquent specimen of Ottonian fresco painting, likely from the final quarter of the tenth century. (ill. p. 10). Otto Demus included this highly narrative fresco sequence as an outstanding predecessor of the Romanesque style in his standard work, published in 1968.

Now, it would be historically incorrect to subsume developments in European countries outside the empire's borders either under the Carolingian or Ottonian epoch, and classify them according to the reigns of German emperors and kings. In this case, more neutral terms are needed. We speak of pre-Romanesque or early Romanesque in order to characterize developments that led to the "true" Romanesque. In general, we can say that the Romanesque style had established itself everywhere by the middle of the eleventh century, after a preliminary and transitional phase lasting about five centuries. Its culmination came in the twelfth century, although in some cases already overlapped by emergent Gothic. Remember that the years immediately prior to 1150 brought the incunabula of Gothic sculpture and architecture in Chartres and Saint-Denis (ill. p. 11). While the crown domain of France and neighboring regions immediately adopted the new style, later to be vilified by Vasari, the remainder of Europe initially proved rather unimpressed by this revolution in art. Romanesque churches were still being erected in a few Italian provinces as late as the thirteenth century, and Romanesque sculpture continued to live on a century longer in remote areas of Apulia and Portugal. In Germany, it was only in the course of the early thirteenth century that the Gothic style imported from France or inspired by French models began to find widespread acceptance.

c. 1020 — A Christian Norman state is founded in Lower Italy
1020 — Beginning of building of St. Sophie's Cathedral, Kiev, the oldest stone church in Russia

> **"It was as if the world had renewed itself, cast off the old, and everywhere donned a glorious robe of churches."**
>
> Raoul Glauber, Cluniac, in his chronicle for the year 1003

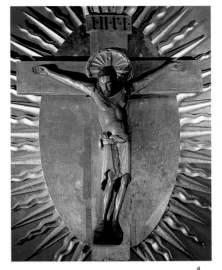

2. PISA, CATHEDRAL, BAPTISTRY AND CAMPANILE ON CAMPO DEI MIRACOLI

begun 1063

3. HILDESHEIM, ST. MICHAEL'S

1010 – 1033

4. THE CRUCIFIX OF ARCHBISHOP GERO

between 970 and 976, wood, height 187 cm,
width (crossarm) 165 cm
Cologne, Cathedral

4

New political and social orders

The late eleventh and the twelfth centuries saw the consolidation of existing centers of state power and the establishment of new ones. It was the hour of the gathering Reconquista in Spain, when, with the aid of adventurers and crusaders, the borders of the Christian kingdoms were pushed southwards against the Moors, who had occupied large areas of the Iberian peninsula since 711. In 1031 the Arabian central state of Córdoba, whose last ruler, Al-Mansúr, had repeatedly attacked the small Christian kingdoms to the north, collapsed. Marching from Castile, Alfonso VI advanced the reconquest by taking Toledo in 1085. Then he had to deal with the Almoravida, fanatic Berber warriors whom the Emir of Seville had called to his aid. These jihad forces were augmented by the Almohada, whom only the knights of the orders of Alcántara, Calatrava and Santiago were able to suppress. The Christian victory in 1212 at Las Navas de Tolosa marked the end of Moorish dominion, even though tenacious retreating battles continued to be fought for almost three centuries.

In France, the Capetian kings of the eleventh and early twelfth centuries inherited the immeasurable prestige of the Carolingian monarchy – though they lacked real power to the same degree. By comparison to the political and territorial situation in the Holy Roman Empire, France of the day was a scene of considerable territorial fragmentation.

This disintegration was dramatically amplified by the increasing power of particular regions. There were potentates on French soil who had more economic and political resources at their disposal than the king in Paris. Foremost among these was the Duke of Normandy, who simultaneously occupied the English throne. Due to the unity and strength of his territorial and military organization, he could rightly consider himself the most powerful sovereign in twelfth-century Europe. The duke's dominion and sphere of influence began only a few kilometers west of Paris. Pontoise already belonged to the archdiocese of Rouen, and the archbishop of Rouen was a vassal of the Anglo-Norman king.

Likewise more powerful than France's anointed ruler were other immediate neighbors of the crown domain – the Dukes of Champagne and the Duke of Flanders. Flanders could boast of being the most important economic center north of the Alps, a land of veritably immeasurable wealth in the twelfth century. What help was it to the king in Paris to nominally be these noblemen's liege lord when his overweening neighbor to the west had yet to swear an oath of allegiance for Normandy, and when his privileges entailed no real power? Louis VII († 1180) put this incongruency in a nutshell when he bitterly

1024 — The Salians supplant the Ottonians on the imperial throne
1032 — Kingdom and Free Duchy of Burgundy, and with it Switzerland, incorporated into the Holy Roman Empire

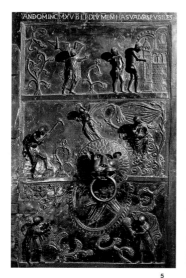

5

6

remarked to the English courtier Walter Map, "The German emperor has good knights and warhorses, but no money, no silk or other luxuries. Your lord, the King of England, on the other hand, knows no dearth; he has men, horses, gold, silk, precious gems, fruit, deer – just everything. But we in France have nothing, except bread and wine and much cheer".

With the conquest of Britain by the Normans in 1066, depicted in the renowned *Bayeux Tapestry* (ill. p. 29), the island entered a new sphere of influence. Its Nordic Scandinavian ties were supplanted by Norman French, which were to last for three quarters of a century.

When Henry I of England died in 1135, the question of succession again proved highly thorny. There ensued twenty years of changing rule, numerous military campaigns, and stabilization attempts. In the end, the confused situation was resolved by an invasion: in 1153, when Henry Plantagenet embarked with his army from French soil to England. On 19 December of the following year, he was crowned King Henry II of England. The land now had a new dynasty and the impetus to an expansive, continental European policy. In philosophy and art, the English elite oriented itself to France. By now, towards the end of the twelfth century, France had gained intellectual hegemony in Europe, not least with the aid of the University of Paris (Sorbonne), whose systems of thought profoundly suffused theology, the fine arts, and poetry.

The revival of the empire under Otto the Great in the second half of the tenth century had led to renewed contacts between Germany and Italy. On a global political level, however, the Roman campaigns of the German kings proved fateful, because they led to permanent conflicts with the papacy in which the central power of the empire exhausted its forces. On the other hand, the revival of the arts brought about by the cultural confrontation with Italy and its ancient heritage triggered impulses with far-reaching consequences.

Imperial policy affected not only Italy but, from the reign of Henry III (1039–1056) onwards, Eastern Europe as well. In 1046, the dukes of Bohemia, Poland and Pomerania paid him their honors. Like Hungary, these lands now stood open to Western influence after having adopted Christianity from Rome rather than from Constantinople. Scandinavia, in the meantime likewise Christianized, entered the Western World as an active if initially marginal partner. All of these developments reflected the fact that, since the eleventh century, core Europe was no longer subject to invasions from outside – by Vikings, Magyars, Saracens – but instead was now in a position to itself pursue a policy of expansion. The Normans wrenched southern Italy and Sicily from the Arabs; here, in 1130, the pope crowned Roger II king of an empire which would soon advance to become one of the key forces in the Mediterranean and a main rival of Byzantium.

1035 — Castile and Aragon become independent kingdoms
1042 — England liberated from Danish rule

1037 — Turko-Muslim Seljuks come to power in Chorassan

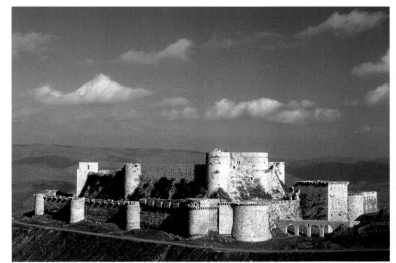

7

8

The crusades and the temporary occupation of the Holy Land, finally, further expanded the geopolitical sphere of the West. Geographically speaking, the Romanesque world now extended from Scandinavia and Iceland to Sicily, from the Atlantic to the Vistula River and Transylvania, and, in the twelfth century, to the Latin kingdoms in Asia Minor (ill. p. 11).

The struggle between Emperor and Pope

The ability of the Roman Catholic Church to call the tone in the concert of powers owed above all to its most active "shock troops", the religious orders, whose reform movement under the leadership of deeply pious men fought clerical corruption and decay. The significance of the German, Flemish, and English monastery reforms of the tenth century was far surpassed by those that began in Cluny in Burgundy.

Cluny Monastery, founded in 910, developed into the hub of a huge organization to which nearly 2000 branches belonged. Their united aim was to contribute to an ethical renewal of the papacy. This could not help but give rise to an existential conflict between the growing authority of the church and the secular empire, which ultimately issued in the weakening of the imperial idea. In Ottonian tradition, the investiture, or appointment, of bishops by the king was a key pillar of secular rule. This was primarily because it bestowed a significant limitation upon the influence of the nobility and their interest in forming dynasties. From the turn of the millennium, Cluny mounted tenacious resistance to just this influence on the part of high-ranking laymen in the bestowal of ecclesiastical honors. The Investiture Controversy developed into one of the most important caesuras in the Romanesque epoch.

The situation escalated in 1075, when Pope Gregory VII assumed the right of dismissing bishops or relieving them of their oath of allegiance to secular powers. The pope even claimed the right to compell emperors to abdicate. Henry IV countered by attempting to force the pope from the Holy See, but Gregory immediately replied by excommunicating him. Henry saw only one antidote against this ban that released the faithful from the duty of obedience to the emperor. By means of his famous and notorious penitential visit to Canossa in 1077, he convinced the pope to lift the ban. It was not until the Concordance of Worms in 1122 that the Europe-wide conflict between "imperium" and "sacerdotum" was resolved. The church emerged from it as a power factor whose influence permeated every nation and all fields of life.

1043 — The Normans wrest Apulia from the Arabs
1054 — Schism between Latin and Greek Church

c. 1050 — Emergence of city privy seals

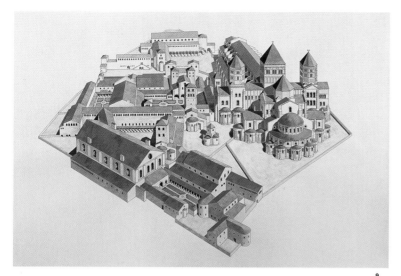

9

10

From the eleventh to the early thirteenth century, the giant church of Cluny, seat of the Benedictine Order that supported the reform of the papacy, stood symbolically opposed to the enormous imperial cathedrals in the Rhinelands. The empire, which like the pope derived its legitimacy from Christ as ruler of the universe and was supported by many high churchmen, did not relinquish its position without a fight. Especially in the twelfth century, the beleaguered empire launched a propaganda campaign of unprecedented extent. The battle between these two power factors and key ideologies in the Western World apparently played a considerable part in the monumental character assumed by Romanesque art.

Due to vandalism during the French Revolution, unfortunately little remains of the third structure of Cluny monastery church. Begun in 1088, it was completed in the second decade of the twelfth century. Until the sixteenth century and the new St. Peter's in Rome, Cluny remained the largest church of Western Christianity. Extensive excavations and numerous visual sources give us an idea of its former appearance (ill. p. 12). The five-aisle nave was almost one hundred and ninety meters long and thirty meters high. Especially the eastern section of the church, with a long transept adjoined by a five-aisle choir and gallery with five chapels and flanked by a further, lower transept, rose stepwise like a mountain chain into the air, and was topped by a staccato of many spires. The interior was overarched by barrel and groined vaults. The decoration amounted to a truly magnificent display. Apart from the wonderful capitals (ill. p. 12), every arch, window and cornice was framed with bands of sculptural ornament.

The sumptuous painting on all architectural features was supplemented by fresco work, carpets, huge wheel-shaped chandeliers, figures of saints, gem-encrusted liturgical vessels – in short, the entire gamut of the wonders of Romanesque ecclesiastical art. At about the same period, the cathedral of Speyer, a building of unprecedented dimensions on imperial soil, was rising as a demonstration of unbroken imperial power. Four Salian emperors and two of their wives found their last resting place in the cathedral. Begun under Conrad II around 1027–1030, Speyer was completed under Henry III in 1061, and converted and completely vaulted under Henry IV. Massive walls of an unprecedented thickness went up, their plasticity underscored by richly modelled and decoratively structured articulating features. On the exterior, the same effect was achieved by means of numerous blind niches and dwarf galleries. Especially the eastern parts of the cathedral, finished in 1137, today still count, despite partial alterations in later centuries, among the most impressive building complexes not only of Romanesque but of all medieval architecture (ill. p. 13) – an

1059 — Cardinals granted exclusive right to elect popes **1061 — The Normans begin the conquest of Sicily**

1063 — Commencement of rebuilding San Marco in Venice

"At that time the glorious Emperor Henry erected that great and admirable church of Speyer in honor of the Everlasting Virgin, whom he especially revered, with royal generosity".

Ebbonis vita Ottonis episcopi Babenbergensis

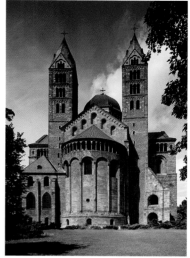

9. CLUNY III – RECONSTRUCTION

10. THE FOURTH NOTE OF THE GREGORIAN CHANT
1115–1120
Capital of a column in the cloister of Cluny
Monastery Church
Cluny, Musée de Farnier

11. SPEYER, CATHEDRAL (EAST SECTION)
largely 1082–1106

11

imposing gesture of power in stone, in the midst of the rivalries of the Investiture Controversy.

A world in Turmoil

The issue of investiture as a church prerogative even in matters of secular power, could perhaps only have arisen in an era that was profoundly marked by pious notions of the afterlife. In an era of far-reaching monastic reform movements, great pilgrimages, and crusades, the entire Western World was gripped by a passionate religious activity that included all estates and strata of the population. The catalyst, as mentioned, was the monasteries. In addition to the venerable and wealthy orders of the Benedictines and Clunians, the twelfth century saw the spread of the ideal of poverty, to which reform orders like the Premonstrians and especially the Cistercians pledged themselves. The latter, under the great Abbot Bernard of Clairvaux († 1153), developed an early mystical theology that was propagated especially in the widely effective media of scriptures and sermons, and occasionally in book illustrations. Chapter rules, initially strictly followed, prohibited any ostentatious furnishing of monastery churches. As a rule, only painted crucifixes were allowed. This must surely have encouraged the spread of panel and icon painting, long practiced in Italy, into central and northern Europe during the Romanesque period.

During that era, the strict discipline that regulated monastic life became the motto of an entirely different caste (whose maxims would remain valid down into the Gothic era). Towards the end of the eleventh century, theologians projected the long familiar idea of the "militia Christi", or chivalry of Christ, onto secular warriors and lords. The church consciously initiated and directed this process in order to quell the continual feuds of the pugnacious nobility and turn their fighting spirit to more "profitable" ends. Clerical ideologists had no trouble in defining the crusades they envisioned as armed pilgrimages, and especially worthy ones, because they were undertaken in defense of the Holy Lands. That was the premise under which knights from Champagne and Burgundy who were planning a pilgrimage to Spain were enlisted by the pope in 1063 to engage the Moors there. Should they lose their lives in battle, the pope, as successor of St. Peter, holder of the keys to paradise, promised them a reward in heaven. In the name of Christ, these chevaliers stormed Barbastro, a Saracen city rich in money and women.

Thirty-two years later, another pope propagated an even more attractive destination. On 27 November 1095, at the Council of Clermont, Urban II summoned Christianity to the first armed campaign to

1066 — The Battle of Hastings 1066–1071 — Reconstruction of church in Montecassino under Abbot Desiderius
1075 — Beginning of the Investiture Controversy 1077 — Conquest of Jerusalem by the Seljuks

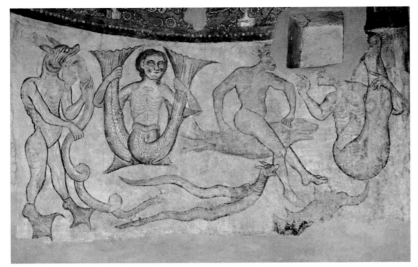

12

Palestine. In this just war against the unbelievers, the soldiers of God ("milites Dei") could win pardon for their earthly sins and an eternal reward. Those, preached the pope, "who were robbers for so long should now become Knights of Christ... Turn the weapons which you have so culpably bloodied in mutual murder against the enemies of the Faith and Christianity". Chain mail singlets, helmets, shields and a forest of lances were now directed against the "Forces of Darkness" – as book miniatures from this point onwards showed.

In 1099, the crusader armies took Jerusalem in an unimaginable bloodbath, and subsequently founded the kingdom of that name and further crusader states. In 1145, Bernard of Clairvaux preached the Second Crusade, which was headed by the German King Conrad III and King Louis VII of France. This enterprise turned out to be a spectacular failure. In 1187, Jerusalem fell to the onslaught of Saladin. The attempt to regain lost territories in the Third Crusade of 1189–1192 miscarried.

The question of the extent to which art, especially painting in the Christian kingdoms in Syria and Palestine, followed its own norms and fed back into Western art, still remains to be definitively answered. But the crusades did indisputably bring one thing – an increasing influence of Byzantine and Arabian culture on the West, the latter above all in intellectual, philosophical, and scientific fields, and in speculative cosmology, by passing on ancient sources and their own insights to Western universities. Analogous Arabian influences made themselves felt in art as well: in silk embroideries, carpets, and other textiles, leading, as the sources report, to a luxury in the furnishing of secular residences until then unknown in the West. In addition, the expansion of intellectual horizons in Europe sparked an interest in geography and reports on miraculous happenings, fabulous creatures from "the edge of the world", which now began to populate Romanesque sculptures, book minatures, and frescoes (ill. p. 14).

European society possessed a remarkable mobility in the Romanesque period. This was exemplified by the masses of pilgrims who were underway on the roads in the twelfth century, whose numbers would never again be rivalled. Uncounted hordes flocked to the graves of apostles and martyrs in Rome, but also to the reliquaries of St. Nicholas in Bari or the temple of Archangel Michael on Monte Gargano. On the way they visited Lucca with its *Volto Santo,* a miracle-working wooden cross with a clothed Christ (ill. p. 15). Numerous copies of this cult image in England, Catalonia, and in Brunswick Cathedral *(Imerward Crucifix)* (ill. p. 15), attest to the receptive effect of such pilgrimages, as do the many St. Michael's churches on mountains (such as Mont-Saint-Michel), which as it were recapitulate the shrine at Monte Gargano.

12. LEGENDARY CREATURES

c. 1220, frescoes
Kastelaz (South Tyrol), St. Jacob's

13. IMERWARD CRUCIFIX

after 1173, wood, height 270 cm, width 266 cm
Brunswick, Cathedral (formerly chapter church
of St. Blasius and St. John the Baptist)

14. VOLTO SANTO

beginning of the thirteenth century, wood crucifix
(copy of a considerably older predecessor),
height of cross 4.34 m
Lucca, San Martino Cathedral

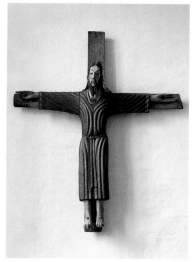

13

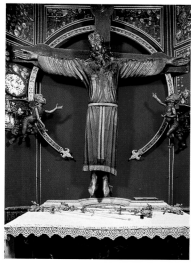

14

Even more important was the pilgrimage to the grave of St. Jacob in Santiago de Compostela (ill. p. 77). The pilgrims approached this destination in northwest Spain by predetermined routes, usually crossing through France. This peregrination not only expanded people's horizons and intellectual flexibility; it also rapidly made artistic tendencies familiar throughout Europe. Cloisters and churches, hospitals and bridges, closely related in style and technique, soon rose along the routes to Santiago. The same type of pilgrimage church is found in Limoges, Conques (ill. p. 17), and Toulouse, and stylistically related sculptures in Toulouse and Santiago. Artists among the pilgrims brought home reminiscences of churches and works of art from foreign lands, and transposed their stylistic language to their own works.

Inspired by this transfer of experience, things at home were likewise set in motion. Cultural life in the castles and at court unfolded in an unprecedented abundance and condensation, as seen especially in the architectural elaboration of aristocratic seats and in an emergent patronage, from which poetry profited most.

Aristocratic culture served as a welcome model for the patricians in the towns. Many territorial lords even moved their courts to prospering communities. The process of urbanization profoundly determined the approximately two centuries of the Romanesque era. In

Germany, for instance, the number of towns increased from about 150 to about 1000. Paris was perhaps the only city north of the Alps to count 100 000 inhabitants. In Upper Italy there were cities with a population exceeding 10 000, almost as many of them as in the rest of Europe together. Urban culture brought forth innovative forms of commerce, law, and social arrangements. The towns, at least regionally solidly established and enjoying an active trade, naturally furthered a closely woven cultural network that spread across the European map. This was not least the reason why Romanesque art, despite its many regional "dialects" arising from national peculiarities, possessed a basic vocabulary that permitted an elementary stylistic consensus to be reached.

europe under the cross?

Let us repeat the question raised at the beginning of the preceding chapter: Was the Romanesque an exclusively religiously determined period in medieval Western history?

A glance at the art of the period seems to corroborate this conventional and so widely accepted view – the imposing churches, the sculptures in and on them, the frescoes and mosaics on their walls, the

1093 — Anselm, the "Father of Scholastics", becomes Archbishop of Canterbury 1098 — Establishment of the Cistertian Order
c. 1100 — First flowering of the Universities of Bologna (Law School) and Paris (Sorbonne)

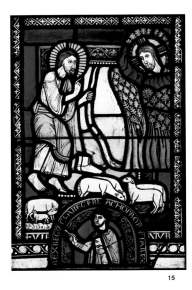

15. MOSES AND THE BURNING BUSH

c. 1150–1160, socle pane of a Romanesque round-
arched window from Arnstein, 52.5 x 50.5 cm
Münster, Westfälisches Landesmuseum für Kunst
und Kulturgeschichte

16. SAN GIMIGNANO

View of city with twelfth- and thirteenth-century
residential towers

**17. CONQUES (AVEYRON), SAINTE-FOY
PILGRIMAGE CHURCH**

built between 1035 and 1200

15

panel paintings on and around the altars, the reliquaries, the exquisite-
ly decorated liturgical appurtenances. Yet a study of the intellectual life
of the period makes us cautious about answering the question too
simply.

In France, the twelfth century saw the development of the philo-
sophical and theological edifice of early scholasticism, which at-
tempted to find rational proofs for Christian faith and doctrine. At the
cathedral schools of Chartres and Paris, the purely idealistic approach
of Platonism was supplemented by Aristotelian logic, and scholars
consequently bolstered explanatory models based on reason by a dic-
tion derived from a study of ancient Greco-Roman sources. An awak-
ening antiquarian interest was expressed in new types of literature,
such as the "Mirabilia Urbis Romae", written circa 1150, which apart
from pilgrimage goals in Rome described and praised the sights of
classical antiquity.

The period known as "the renaissance of the twelfth century"
was followed by a long phase of intellectual sterility. New universities
were now founded at which not only church and civil law were taught
– disciplines in which Bologna excelled – but increasingly the seven
liberal arts, no longer beholding to pragmatism. Twelfth-century hu-
manism, represented above all by the school of Chartres, was based
on the study and commentary of the classics. Many Greek texts pre-

viously unknown in the West were translated into Latin from the ori-
ginal or from Arabic versions. This intellectual climate proved infec-
tious: theological authors like the brilliant Peter Abelard (now known
more for his tragic love for Heloise) embraced every opportunity for
intellectual speculation

In view of the history of ideas just previously outlined, the crucial
question arises as to whether and how such intellectual developments
affected art. This seems to have been most likely the case in the field
of architectural sculpture and its occasionally educational purpose.
Only a very few murals or frescoes, on the other hand, reflect the
theological hairsplitting of the day, and when they do, it is usually in
the form of repetition. Phenomena such as the long preparing and
now emerging social order of feudalism, or the new courtly and chiv-
alrous status-consciousness reflected in troubadour poetry or heroic
epics, are too differentiated, come at far too differing points in time
in different countries (and are hardly found at all in northern and cen-
tral Italy), to permit of any general explanatory model for a universal
artistic development. It is quite imaginable, on the other hand, that the
notion of order underlying the feudal system – the idea of a God-given
universe established once and for all time – may well have significant-
ly contributed to the clarity of the compositional structure of Ro-
manesque art.

c. 1100 — In Romanesque church architecture, groined vaulting replaces previous flat roofs in naves
1119 — In Rome, decrees protect Trajan and Marcus Aurelius Columns from wanton destruction

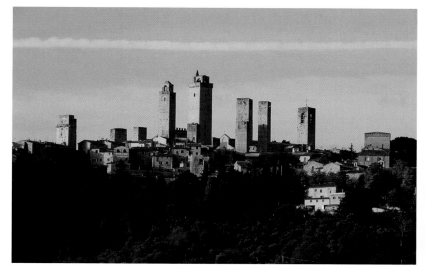

16

17

In general, Romanesque literature seems to reflect the current image of the world most directly and clearly. Alongside the lyrics of the troubadours and the epic "Chansons de geste", more and more genres written in the vernacular burgeoned, including the Icelandic "Sagas", the romances about King Arthur and the Round Table, the adventures of Alexander, and the "Nibelungenlied". Above all, however, it was historiography that was revived in the twelfth century and experienced a tentative "secularization", in the form of annals, chronicles, and biographies, some even in connection with the lives of saints.

But let us return to the visual arts and architecture. These fields by no means evinced only sacred works. Recall, to give only a few examples, the countless castles and palaces of the era, or the twelfth- and thirteenth-century residential towers in San Gimignano, which have long become a prime tourist attraction (ill. p. 17). But let us also recall the invective directed by Abbot Bernard of Clairvaux against the at best decorative, at worst "monstrous", but always expensive architectural sculpture of Romanesque churches and cloisters. His argumentation bristles with the word "curiositas", which it is fair to translate "visual pleasure". Such things capture "the gaze of the worshiper and hinder his attention … One admires them more than one reveres holiness … The monies for the poor are squandered for the visual delectations of the rich".

Under the surface of this polemic lurks a highly significant admission. The era copiously practiced this derided "curiositas", and the church itself regularly employed this "profane" visual pleasure as a means of "public relations" with the faithful.

The still widespread notion that medieval and especially Romanesque art was solely the achievement of monks or deeply religious lay artisans who were animated solely by service to the church, is contradicted by many written sources of the twelfth and thirteenth century. Let us list only a few:

The description of the transfer of relics to the new cathedral of Durham in 1104, written in 1175 by Reginald, an English monk, is evidently an eye-witness report. The body of the saint was wrapped in embroidered cloths that prompted the reporter to true paeans of enthusiasm. Suddenly the aesthetic appeal of nuances of color and the brilliant composition of a decorative pattern took on greater weight than their sacred meaning. A second example: The chronicles of the bishops of Le Mans contain a detailed report about construction work undertaken by their prelate, William, in the period around 1158. William, we read, had a private chamber built for himself, wonderfully illuminated by windows "whose artistic worth even surpassed the exquisiteness of the materials … Next to this room he erected a chapel, and while the architecture of this chapel itself was a work of marvellous

1121 — Concordance of Worms and temporary end of the Investiture Controversy
1137–1144 — New construction of Abbey Church of St. Denis under Abbot Suger

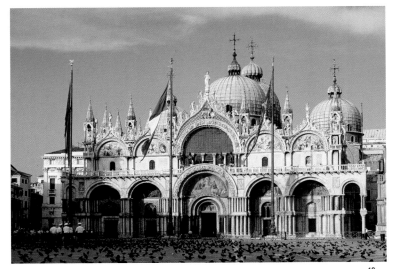

beauty, the pictures painted on its walls with admirable skill, which very precisely reproduced the appearance of living creatures, captured not only the mind of the spectators but their spirit, captivating their attention so completely that they forgot their own business over an enjoyment of the pictures".

Not a few twelfth-century descriptions surprise us with their great enthusiasm for colors, illumination, splendidness, and rich contrasts of effect. In the meantime, these treasures – gold and silver, often gem-encrusted vessels, radiant windows, and sumptuously colored tapestries – have largely disappeared, especially those once harbored in the castles and palaces of kings, noblemen, and many a wealthy merchant. This explains the erroneous yet widely accepted modern picture of Romanesque art as an art of asceticism, naked stone, the spiritual emptiness of interiors, reflecting a sole concentration on the life after death. A cliché, indeed, which art historical investigation has long since countered, as it has proven the legend of the anonymous medieval artist whose works represented a worship of God in concrete form to be a one-sided romantic fiction. Naturally the theological and liturgical aspect of many works of art remained the indisputable guideline for patrons and artists. Still, complex demands of a secular, propagandistic kind were made on artists, who were proud to be capable of meeting them.

Consequently, artists' signatures and "self-portraits" are no rarity in the eleventh and twelfth centuries. An especially beautiful example is the painted pane of a round-arched window, datable to 1150–1160. While its main section shows Moses before the burning bush, below him is to be seen the monk Gerlachus, both creator and donor of this stained glass, who identifies himself as a painter by means of a pot and brush (ill. p. 16). Such instances reflect the self-confidence of artists at this period and their imitation of corresponding personal messages contained in classical ancient art. The Burgundian sculptor Giselbertus inscribed his name highly visibly on the tympanum at Autun (ill. p. 61); the Italian Wiligelmo, sculptor of Modena Cathedral, set himself a monument in the following inscription: "Inter scultores quanto sis dignus onores. Claret scultura nunc Wiligelme tua" (Among sculptors, how worthy are you of honors. Now, Wiligelmo, your work shines out).

The social composition of art patronage also underwent a process of transformation. While around 1100 the high ranking, and the highest ranking clergy were foremost in this field, they were subsequently joined by prebendaries, other clerical communities, and increasingly by members of the upper-middle class, who contributed to the realization of even the most ambitious sacred projects, for instance church buildings or monumental reliquary shrines. An interest-

1138 — The Hohenstaufen Conrad III becomes king
c. 1140 — The fine art of Arabian silk weaving reaches Sicily
1144 — Europe in the grip of a terrible famine

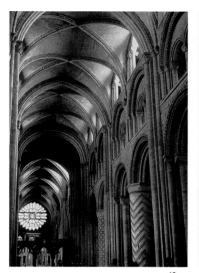

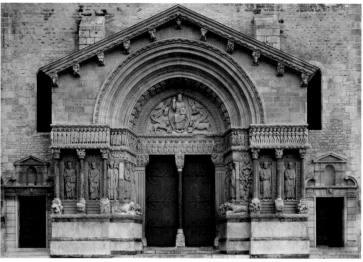

19

20

ing example of this are the frescoes of San Clemente in Rome, which were donated by the daughter of a wealthy butcher.

The concert of arts

Despite the plea for a greater appreciation of the secular side of Romanesque culture, there can be no doubt that ecclesiastical buildings were the main focus of the epoch, building activity indeed becoming feverish in the eleventh and twelfth centuries. Every field of art had its contribution to make. Unlike the exteriors of early Christian churches, as a rule undecorated shells, now massive walls fitted of carefully hewn blocks (categorically different from the broken-stone masonry of earlier centuries) rose into richly layered structures, some with twin-tower facades and crowned with further spires, especially above the intersection of nave and transepts. Their monumental overall effect resulted from the sum of clearly and functionally defined parts.

In the interior, significant church buildings additionally showed an articulation of wall volumes by means of choirs and galleries, and the roofing of high and wide spaces by groined and cross-ribbed vaulting. The latter, which Gothic was to take up, was favored especially in Anglo-Norman architecture, the ribbed vaulting in Durham Cathedral

being a prominent case (ill. p. 19) because it has erroneously been dated as far back as 1093. In Normandy, rib-vaulted naves did not develop until about 1120–1130.

The ground plans of Romanesque churches were basically not new. What was new was an accentuation of the eastern section, the choir, by a group of staggered apses or a choir gallery with a wreath of radial chapels. The adoption of the basilica as the dominant spatial configuration of churches, and individual Romanesque elements like barrel vault, capitals, and other decorative forms, went back to classical architecture. In the former Roman provinces, especially in Burgundy and Provence, much of Romanesque architecture is indeed defined by the use of the entire classical wall structure. In parts of Italy, a very close reliance on late antiquity (in the so-called Tuscan "proto-Renaissance" or Florentine incrustation style – to which San Miniato al Monte, mentioned above, belongs) as well as on Byzantine models can be detected. This is most wonderfully demonstrated by San Marco in Venice (ill. p. 18), which began to rise in the mid-eleventh century.

In the decades around 1100, European art was suffused by an intention that would have far-reaching consequences – a recourse to monumental sculpture. At the end of the eleventh and in the course of the twelfth century, sculptures on a massive scale appeared in Burgundy, in the south, west, and southwest of France, and in a few places

c. 1150 — Arabs introduce the technique of paper manufacture into Europe on a broad basis
1161 — The "Constitutum Usus", the earliest trade and maritime law, enacted in Pisa

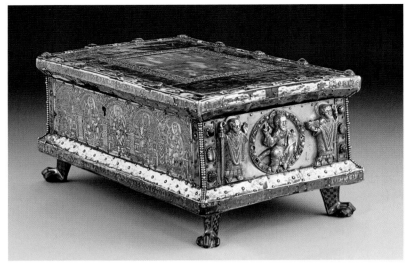

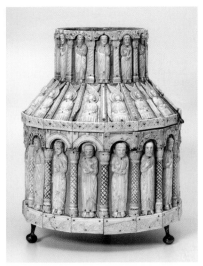

in northern Spain. They occupied the tympana (arched recessed fields) over the portals of monastery churches in Burgundy, in Toulouse, Moissac, León, and Santiago de Compostela, and the impressive portal configurations of Provence, such as that of Saint-Trophime in Arles from the last third of the twelfth century (ill. p. 19), whose figures clearly reflect the influence of classical models. In western France, for instance in Poitiers, entire facades are covered with stone sculptures (ill. p. 21).

Now the human figure appeared in Western art, indeed the image of God or visionary scenes of the Last Judgement, sculpted on a monumental scale and taking effect in the "public space" with compelling drama. Such architectural sculptures were not intended for worship, contained no relics, nor had any liturgical function – their appearance was determined solely by their integration in the church building and the resulting semiotics and semantics. This distinguished these sculptures categorically from the crucifixes and figures of saints on the altars, in fact from every type of mobile fixture in the churches, which Romanesque art naturally also employed, and that to an increasing extent.

The range of subject matter began to expand. In addition to divine and holy personages, the iconographic hierarchy came to encompass human beings and animals, and a whole army of demons. Yet realistic representation was avoided, and not only in the case of fantastic creatures. Every configuration was built up of rather complex, quite independent individual parts. The specifically dominant aspect was either blocky, dignified, hieratic stasis, or an ecstatic swirl of limbs that negated organic form and was locked into the plane – in short, the transcendental force of abstraction took precedence to the essence of figuration.

Church furnishings set off an opulent fireworks of artistic ingenuity – in the media of goldsmithing, metalwork, and ivory carving (ill. p. 20), in liturgical appurtenances and reliquaries, but also in baptismal fonts, altar superstructures, and altar coverings such as the Scandinavian "golden altars" (ill. p. 63). Metalworking skills in the Holy Roman Empire had already reached a zenith in the Carolingian and especially in the Ottonian period. This tradition was continued during the Romanesque in Lower Saxony, the Maas region, and regions along the Lower Rhine. The reputation of excellent Germanic artisanry found an echo, for instance, in the term "opus teutonicum", or German work, applied to a grid of bronze, gold and silver in the Beverley Minster, Yorkshire, c. 1065.

The refined techniques of Romanesque metalwork were fortunately recorded in the early twelfth-century tract "Schedula diversum artium". Its author was very likely a monk and bronze caster from Hel-

c. 1177–1181 — Chrestien de Troyes writes his Lancelot romance c. 1180 — In England, glass windows installed for the first time in private houses 1187 — Saladin reconquers Jerusalem from the Christians

21. ROGER OF HELMARSHAUSEN: PORTABLE ALTAR (KILIAN-LIBORIUS PORTABLE ALTAR)

c. 1100, oak box, clad in partly gilded sheet silver, feet of gilded bronze, height 16.5 cm, length 34.5 cm, width 21.2 cm overall
Paderborn, Cathedral

22. THE "GREAT" TOWER RELIQUARY

c. 1200, Cologne workshop, wooden core, gilded plaster facing, ivory carvings, copper plate as base, height 36.5 cm, lower diameter 26 cm
Darmstadt, Hessisches Landesmuseum

23. POITIERS (VIENNE)

c. mid-twelfth century
Former Collegiate Church of
Saint-Hilaire-le-Grand, west façade

In the preface to the first volume of the *schedula,* Theophilus [Roger of Helmarshausen] describes himself as an "humilus presbyter, servus servorum Dei, indignus nomine et professione monachi" – "a humble priest, servant of the servants of God, not worthy of the name and office of a monk."

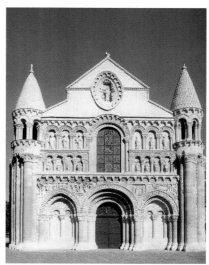

23

marshausen in Lower Saxony (ill. p. 20), Rogerius, whose pseudonym was Theophilus.

In the same artistic landscape, and again in the technique of bronze casting, emerged the first freestanding secular monument in art history, the *Lion of Brunswick* (ill. p. 22).

Painting: Genres and Regions – an outline

The mobility that characterized many walks of life in Romanesque society apparently directly affected the field of painting and associated migrations of artists. Spain was especially rich in examples. The Master of San Clemente de Tahull (ill. p. 49) came from Roda (Huesca); the Master of Pedret, who spread his style throughout Catalonia, had probably migrated from Lombardy. The Master of Osormort, who was schooled in France, was itinerate in the area of Barcelona and Gerona, and the painter who created the (now almost entirely destroyed) decorations in the chapter hall of Sigena very likely originated from England. The Majesty fresco in the Panteón de los Reyes (ill. p. 81) appears to have been based on French sources. In France itself, the frescoes of Nohant-Vinq should probably be considered as the isolated work of an itinerant painter, likely one from Toulouse.

The older parts of the frescoes in Le Puy (second half of the eleventh century) are evidently linked with southern Italy, and the more recent, early thirteenth-century sections suggest contacts with upper Italy. The eleventh-century murals in the village of Maria Wörth in the province of Carinthia evince links with Bavaria; the apse frescoes at Kloster Knechtsteden near Cologne (ill. p. 23) were executed by a painter whose home was presumably Tournai; the decoration in the upper choir chapel in St. Nicholas's in Matrei stemmed from an itinerant Paduan artist.

While in previous periods book illumination largely predominated over large-format painting, in the Romanesque era, despite superb examples of the art of miniatures, painting on a monumental scale – frescowork on walls and ceilings – definitely took on greater weight. In the structure of ecclesiastical buildings the separate fields of art entered a compellingly dense symbolic interweave with the architecture. Almost all of the significant Romanesque churches were decorated with figurative painting and a concomitant, specific "visual theology". Naturally these images were not self-contained pictures, let alone autonomous paintings in the modern sense. They were part of a colored "skin" that stretched over the entire interior, to which the decorative polychrome finish of architectural components also belonged.

1194 — Commencement of building of Chartres Cathedral c. 1200 — Emergence of the "Nibelungenlied"
c. 1200–1210 — Gottfried of Strasbourg authors the romance "Tristan and Isolde"

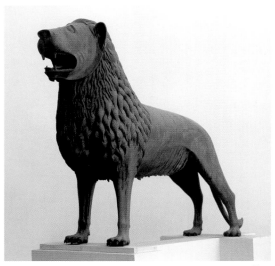

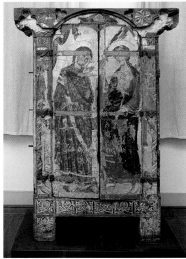

Fresco painting maintained a prominent place until the increasing permeability of nave walls – which already set in in Norman architecture in the late eleventh century and in the late-Romanesque architecture of the Rhinelands in the early thirteenth – necessarily reduced its contribution to the overall effect of church interiors.

An endless amount of the large-scale painting of the era has been lost. It was best, if not exclusively, conserved in regions which later major historical events passed by, such as the Etsch Valley, Catalonia, and a few provincial areas in Italy, France, and Germany. Much more of this art survived in villages than in prospering towns, in chapels and branch churches than in parish churches and cathedrals.

Art historians are in agreement in seeing the twelfth century as the apex of Romanesque painting. At that period its repertoire of characteristic visual principles emerged in pure form: expressive vitality in the pose, expression, and gestures of figures – figures represented not in terms of actual physical appearance but as symbols of transcendental relationships. The figures are neither placed in a fitting spatial setting nor are they organically modelled, but abstracted and arranged ornamentally on the plane. Like the compositions as a whole, the draped figures are compartmentalized and built up of separate parts. Although these sections may be plastically and sequentially articulated, no overall effect of three-dimensionality arises; instead, the

compositions rest on the principle of dynamic formal tensions. And all of this conveys the suggestive impression of having been influenced by early Christian, and especially Byzantine, art.

Like Germany, England witnessed a revival of the visual arts in the latter half of the tenth century. Works from the court school of Charlemagne and the Frankish-Saxon Carolingian miniatures provided the models for a development in painting that issued in the second quarter of the eleventh century in simplified compositions and more monumental visual configurations. Judging by the highly accomplished book illumination on the island, twelfth-century Anglo-Norman monumental painting must have contributed an important voice to the European concert. However, as only a handful of specimens have survived, all from this century and from the southern part of the country, they provide little information in this regard. The losses are of course compensated to some extent by the marvelous *Bayeux Tapestry* (ill. p. 29).

The panorama in Italy is extremely complex. While Upper Italy maintained close contacts with the countries north of the Alps, art in Rome and Lower Italy remained largely beholding to its own laws – in southern Italy and Sicily due to close ties with Byzantium, and in Rome due to a self-confident insistence on local traditions. Wall and ceiling paintings there continued to orient themselves to the mosaic work of the sixth century – the apse decorations in SS. Cosma e Damiano, for

1202 — Introduction of Arabic numerals into Europe 1204 — Fourth Crusade ends with the conquest of
Constantinople and the institution of the Latin Empire 1206 — Mongol princes elect Ghengis Khan as leader

**24. LION MONUMENT TO DUKE HENRY
THE LION**

c. 1163 – 1169, cast bronze, height
178 cm, length 280 cm
Brunswick, Herzog Anton Ulrich-Museum

25. CABINET FROM ST. MARY'S, HALBERSTADT

first half of the thirteenth century, tempera on gesso
ground over parchment facing, height 199.5 cm,
width 105 cm, depth 68.5 cm
Halberstadt, Domschatz (Cathedral Treasury)

26. THREE APOSTLES

c. 1170 – 1180, apse fresco in former Premonstratensian
Abbey Church of St. Mary's and St. Andreas'
Knechtsteden near Cologne

27. MASTER OF THE CROSS NO. 432

end of the twelfth century, tempera on wood,
302 x 230 cm
Florence, Galleria degli Uffizi

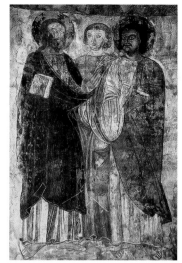

26

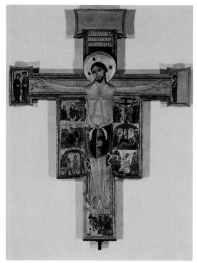

27

instance, were repeated with only slight modifications down into the early thirteenth century.

Spain holds an exceptional position in the history of Romanesque painting. There, mural and panel painting were concentrated in a narrowly defined area, principally the southern valleys of the Eastern Pyrenees. These were largely works of a rural character, although they included masterpieces in noble settings, such as the frescoes in San Clemente at Tahull, in the Panteón de los Reyes at León, and in the chapter hall of Sigena. The fact that Romanesque art production was limited to the north quarter of Spain naturally resulted from the historical factor of the Reconquista against the Moors, which gradually advanced from north to south. It remains a mystery, however, why the great proportion of frescoes are concentrated in the extreme northeast, in Catalonia, whereas only a single work of the twelfth and only a few specimens of the thirteenth century are found in Aragon and Castile.

Whatever the case, the most striking characteristic of Spanish fresco painting is an alienation of figures, which appear assembled from separate parts and whose movements have an inorganic look. Then there is their wild facial expression, and especially the brash palette of the compositions, full of bright-gloomy disharmonies and harsh contrasts.

The art of mosaic can be classified as painting in the wider sense. From the "Chronicle of Montecassino", written by Leo of Ostia prior to 1075, we learn that Abbot Desiderius recruited specialists in Constantinople to execute mosaics in the apse of the monastery church. They were also entrusted with decorating the main façade and the entrances to the vestibule. In addition, we read that this technique had not been applied in Italy for over five hundred years. Now it experienced its renascence, focused on the art regions which possessed close ties with Byzantium – southern Italy/Sicily and Venice. In part, this also held for Rome, where large-area mosaic decorations may be viewed as a recourse to the city's late classical and early Christian past.

A far-reaching achievement of the Romanesque era was the dissemination and monumentalization of stained glass as a pictorial medium, even though there are much earlier literary references to colored windows, such as in Bishop Gregory of Tours' St. Martin's, c. 580, and Saint-Rémi Abbey in Reims, 995. Stained glass is also known, if only in the form of sparing remnants from the Carolingian period found in excavations, from the German monastery at Lorsch. Evidently the complex layering which Romanesque architecture introduced into the structure of walls went hand in hand with the desire for large stained-glass cycles. The author of the artists handbook mentioned above, "Schedula diversarum artium", was the first to give a

1209 — Beginning of struggle against the heretical Catharians (Albigensians) in southern France
c. 1210 — Wolfram von Eschenbach writes "Parsifal" 1212 — Children's Crusade

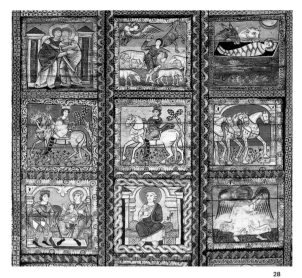

28. PAINTED CEILING

(detail), c. 1130–1140, tempera on wood
Zillis (Grison), St. Martin's

29. PAINTED CEILING

c. 1230–1240
Hildesheim, St. Michael's

30. THE CREATION OF THE WORLD

first quarter of the twelfth century,
embroidered tapestry, 375 x 460 cm
Gerona, Museo de la Catedral

28

step-by-step description of this technique. As the surviving examples indicate, the stained glass of the period is characterized by thick panes, intense colors (with a preference for light blue), and stylized figures reminiscent of those in contemporaneous frescoes and miniatures.

In spite of all innovations, reminiscence and faithfulness to tradition are indeed key terms for an understanding of Romanesque art. Romanesque painting in particular involved no revolutionary rejection of what went before; rather, it represented an imposing nucleus of crystallization within a continuum of tradition that extended from late antiquity to the Gothic. It was no coincidence that in France, where for political reasons there was no interpolation of the Ottonian as in Germany, art around the year 1000 was already referred to as the "premier art roman".

Nor can the end of the Romanesque be marked by any fixed date. Rather, as Otto Demus notes, the era represented a "gradual process of undermining" leading to Gothic, which in Italy, for instance, was prolonged by a stronger tendency to Byzantinisms down to the thirteenth century. As Demus also points out, in artistically provincial regions of the Early and High Middle Ages like Bavaria and Carinthia, Romanesque systems and programs of decoration continued to be employed as late as around 1400.

Panel Painting

Paintings on wood panels hold a very special position in the Romanesque era. Evidently these were most widespread, and perhaps originated, in Italy, where their emergence can be traced back to the earliest medieval period. In addition to antependia (altar screens) and altar retables, crucifixes were among the earliest and most characteristic creations of Italian panel painting (ill. p. 23). These were located behind or over the altar, but most usually on the rood screen separating the priests' room from the congregation. The oldest still extant work of this kind is of Tuscan origin: the crucifix in Sarzana Cathedral, created by a Master Guillielmus in 1138 (ill. p. 65). The iconographic scheme of later crucifixes – combining the main figure with smaller accessory scenes and figures – already appears here full-blown.

A further dated crucifix from the twelfth century is found in Umbria: that by Master Albertus, 1187, in Spoleto Cathedral. Beginning in the later twelfth century, the schools of Lucca and Pisa assumed the leadership in this genre.

When after the conquest of Constantinople by the crusaders in 1204 an abundance of Byzantine works of art, including numerous panel paintings, were brought to Italy, this resulted in a renewed

1214 — The Battle of Bouvines ends English domination in France — 1215 — "Magna Carta" enacted in England
1216 — Founding of the Dominican Order — 1220 — Coronation of Frederick II of Hohenstaufen as Holy Roman Emperor

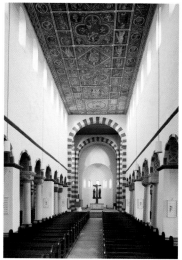

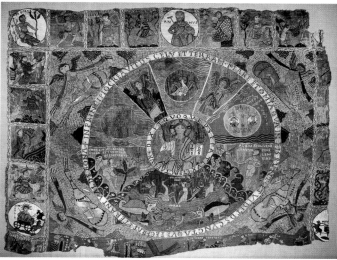

29

30

burgeoning of icon painting. In Italy the Romanesque-Byzantine "Greek manner" established itself, and it was not to be supplanted until just prior to 1300, by the new style of Roman art practiced above all by Cimabue and Giotto.

Only in Catalonia has a stock of panel paintings comparable to that in Italy survived. These consist of a few retables, but mostly of antependia, today largely united in the Museu Nacional d'Art de Catalunya in Barcelona. At the transition from the eleventh to the twelfth century stands the antependium from La Seo de Urgel, with Christ Pantocrator in the center of the panel (ill. p. 41). The Italo-Byzantine influences still evident here were supplanted in the course of the twelfth century by local Spanish and Catalonian tendencies. Otherwise, except in Scandinavia and Germany, we know of only about two dozen examples of Romanesque panel painting, retables, antependia, a few crucifixes, icons, painted reliquaries, and sacristy cabinets (ill. p. 22).

In addition, the German-language region can boast of two further works that hold a singular place in the surviving stocks. These are the painted wood ceilings in Zillis, Switzerland (ill. p. 24), and St. Michael's in Hildesheim, Germany (ill. p. 25). The former ceiling, at St. Martin's in Zillis, originates from the first half of the twelfth century. Comprising 153 square fields, it combines the story of the life and

sufferings of Christ with a cosmological program. The Hildesheim ceiling, created in the first quarter of the thirteenth century, subordinates every motif in the depiction to a representation of the family tree of Jesse.

The Martyrdom of st. vincent

Mural (fresco with secco applications)
Galliano near Cantù, San Vincenzo Basilica

The earliest and most important record of the revival of monumental painting on Italian soil has survived in the northern area of the Apennine peninsula, in the vicinity of Como: the apse decoration in the former parish church San Vincenzo, in Galliano near Cantù.

In terms of its stylistic genesis, however, this mural cycle did not appear suddenly on the stage of this region so prominent in Romanesque art. Apart from the few remnants of the exorbitantly painted fresco sequence in Castelseprio, whose dating has been shifted by perplexed art historians from the sixth/seventh to the tenth century and back, and which may in fact have been executed by a Syrian artist in pre-Carolingian times, reference should be made to the remnants of the decor in the baptistry of Novara, near Milan. These late tenth-century frescoes, inspired by Ottonian art, show a very close relationship with the Galliano murals, dating to c. 1007. Their patron in Galliano was Aribert, future archbishop of Milan, whose donor portrait was once visible in the apse.

All of these frescoes are generally agreed to belong to the orbit of Milan, the old capital of Lombardy, most of whose imposing early Christian churches likely still stood at the time and formed the metropolitan church of a wide region. The next great monument of Milanese painting is found in San Pietro al Monte by Civate, near Lake Como (ill. p. 39).

The mural depicting the martyrdom of St. Vincent of Valencia, sadly in a poor state of preservation, is a drastic and expressive record of the torments suffered in about the year 287, under Emperor Diocletian, by this deacon who has been revered since the fourth century. As the hagiographic sources report, he was thrown naked into a dark tower. His agony began when torturers dislocated his limbs, tore his flesh with hooks, and cast their victim onto a red-hot grate. Yet he was comforted by angels, who transformed the instrument of his final torment into a bed of fragrant flowers.

The composition conforms to the criteria common to the sadly only fragmentarily surviving frescoes of the time: forms of veritably monumental proportions, impassioned, devoted gestures and motions of a surprising aliveness in a picture based entirely on the human figure as the vehicle of the story. This is underscored by the modelling in white accents and highlights, often applied in sharp strokes, and the incredibly rich, original ornamentation. Although all of these features still recall Ottonian or pre-Romanesque art, the fundamental tenor of inward grandeur opens a prospect onto a new visual force – that of the Romanesque proper.

The mural workshop, doubtless headed by a brilliant artist, quite certainly originated from Milan – even though no frescoes of such excellence from this early period have survived to permit a comparison. At any rate, the members of the studio hired by Aribert were familiar with Byzantine models, and probably also with frescoes and mosaics from late antiquity. Working on this basis, they created some of the most superb works produced during the Middle Ages.

"Nearly every Romanesque church was decorated with figure paintings, murals that in fact gave the interiors their true form, that engendered the specific atmosphere of Romanesque faith. The painted walls were a visual echo of the liturgy, encompassing the pious like a protecting and healing shell ..."
Otto Demus, 1968

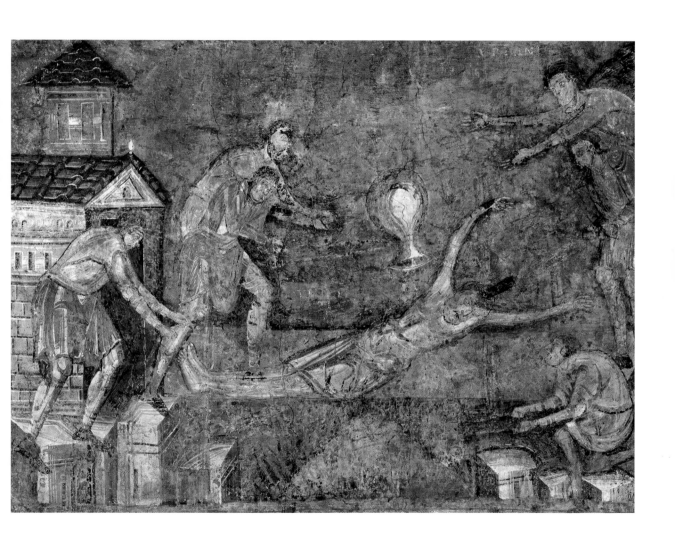

The Bayeux Tapestry

Eight consecutive embroidered linen strips (moiré weave),
height between 45.7 x 53.6 cm, overall length 68.38 cm
Bayeux, Centre Guillaume le Conquérant

The *Bayeux Tapestry* is an impressive example of Romanesque art, but above all, it is one of the most outstanding landmarks of European history. A continuous Latin inscription and a frieze of fifty-eight embroidered scenes report on the Norman conquest of England in the year 1066. The trees and towers interspersed between the separate episodes articulate the events without interrupting the flow of the visual narration. With few exceptions, the events are depicted in the historically correct sequence, each of the protagonists appearing several times. They are identifiable despite the fact that no attempt at portrait likeness was made.

The embroideries were not only intended to visualize an epoch-making military campaign or function as a political manifesto, they were meant to satisfy the need for visual entertainment. The slaughter of oxen, preparation and serving of roast chicken, the abundance of details from military life, the detailed ships and sundry appurtenances of daily life which make this tapestry a unique historical source, must have represented a suspenseful reportage in contemporary eyes. The borders accompanying the main scenes at top and bottom are in part decorative, in part depictions of legends, and in part describe subplots or anticipate things to come. Towards the end, where the Battle of Hastings rages, the lower border is devoted to hordes of bowmen, dead and wounded, and the plundering of casualties – all in a naturalistic style that transcended the norms of the art of the day.

The principle of a visual narration unfolding like a frieze was known from antiquity, as in the reliefs on "Trajan's Column", erected in 113 A.D., and on the "Marcus Aurelius Column", 180 A.D. (both in Rome). There was also the "Joshua Rotulus", a Byzantine parchment scroll of the tenth century, which went back to a late-classical model (Rome, Biblioteca Apostolica Vaticana, Cod. Vat. Pal. Gr. 431). The *Bayeux Tapestry* follows this narrative principle and leads the eye from phase to phase. Not surprisingly, the tapestry's vivid action has frequently been compared to a film or comic strip.

The anti-naturalistic yet quite homogeneous coloration and the often strongly elongated, insect-like figures with their agility and vivid gestures, produce a strong yet by no means coarse or naive overall effect. The suspenseful dramaturgy of the whole transforms the tapestry into a masterwork of the creative imagination.

No other medieval work of art that has come down to us provides such an elaborate description of recently transpired historical events. The few other textile records of the Romanesque period are devoted to religious subjects, as the *Tapestry in Gerona* (ill. p. 25).

This raises the question of the site for which the *Bayeux Tapestry* was originally planned. Many art historians assume that it was made in southern England (perhaps at the St. Augustine monastery in Canterbury) for Odo of Bayeux, bishop and half-brother of William the Conqueror. Mathilde, William's wife, would be an equally likely candidate. Just as difficult as an authentic localization of the tapestry is the question of its patron. Its stylistic unity indicates that it may well have been designed by a single artist. Although some have suggested that the tapestry may have been hung in Bayeux Cathedral to mark a certain festival day, this custom is recorded only since the fifteenth century. A more convincing explanation is that it was hung in the hall of a bishop's palace, be it in Bayeux or in southern England.

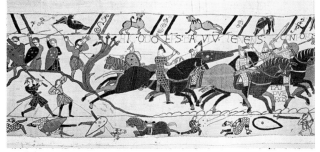

The Bayeux Tapestry, c. 1070, a scene from the battle

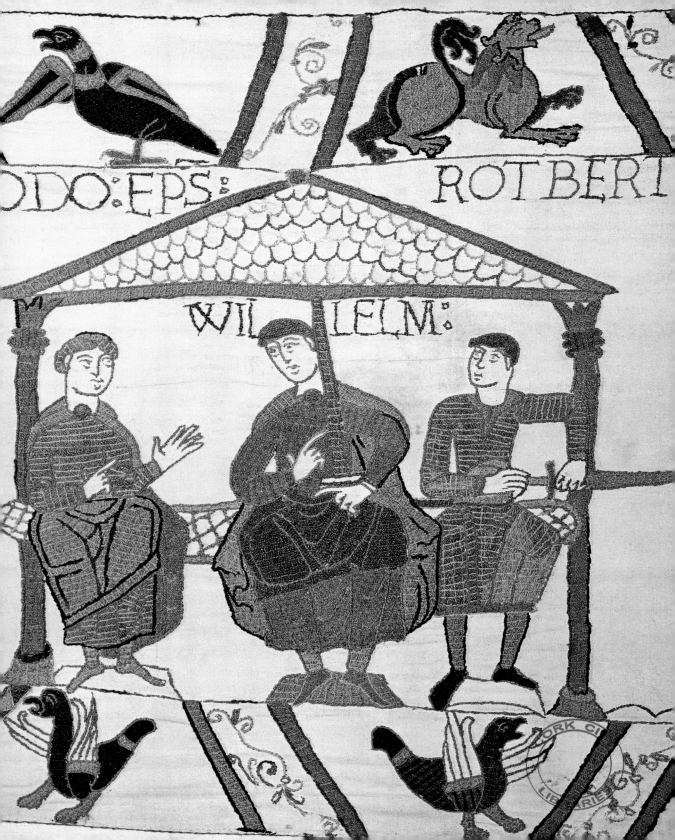

Angel of the Last Judgement

Fresco
Sant'Angelo in Formis, interior entrance wall

Unfortunately no examples of murals have survived in Montecassino, which was once a foremost ecclesiastical center in Italy whose artistic achievements were disseminated through affiliated monasteries in half Europe. Yet on the soil of Campagna we find the superb specimen of a nearly completely intact church building from the early Middle Ages whose entire interior is decorated with frescoes which, most investigators believe, would be hardly imaginable without the erstwhile paintings in Montecassino. This is Sant'Angelo in Formis, near Capua, a filial church of Montecassino consecrated under Abbot Desiderius.

Occasionally, the opinion is voiced that the decoration of the west sections – unlike that in the apses and on the nave walls – might be of later date, from the twelfth century. This may be true of the vestibule. Yet it is now generally agreed that the program of the church space proper was completed around the year 1080.

The donor, Desiderius, is depicted in the main apse, standing with three archangels and St. Benedict in a separate zone at the feet of the enthroned ruler of the world. Three rows of New Testament paintings on the walls of the nave lead to this apse. The larger part of the entrance wall is occupied by a colossal depiction of the Last Judgement, divided into four superimposed registers – a type of composition that would long remain the standard for depictions of this subject. The decorations in the side aisles represent scenes from the Old Testament.

The narrative style is dramatic, with compactly summarized figures and simple, or rather, rectangularly divided areas. The design concentrates on the drama and force of a human statement and a profound empathy with an occasional tendency to popular appeal. Broad, energetic brushstrokes have been used to give the squat figures an extreme expressiveness. The palette is limited to light blue, a yellowish and a darker ocher, a deep brownish-red, an earthy green, and a great deal of chalk white.

It is certain that several artists or assistants were at work here. Still, everything appears unified, stylistically and iconographically at the intersection between Byzantine tradition and innovative Western formal language. Close Byzantine parallels are found in book illumination of the eleventh century in Montecassino; certain Ottonian traits could be derived from local traditions. The group compositions of the Last Judgement around Christ in his glory are populated by figures of praying clerics and laymen of identical size, arranged isocephalically, that is, with their heads on the same level. The damned, in contrast, enjoy no such peace of mind, being forced into tumultuous diagonals, caught in violent movements, crouching and falling, being pushed by blood-red demons into the maw of hell.

Yet everywhere it is the large faces with penetrating gaze that capture the eye, and everywhere even spontaneous movements are stylized into symbolic gestures, organic form subjected to a strict, ornamental pattern. In view of these uniform traits, the paintings in the vestibule, especially the grand half-figure of Archangel Michael, may well not have been done until towards the end of the twelfth century. The similarity between these elegant, well-nigh manneristic frescoes and the best mosaics of Monreale, on Sicily (ill. p. 82), suggests an authorship by a Byzantine master who emigrated from there.

The Last Judgement

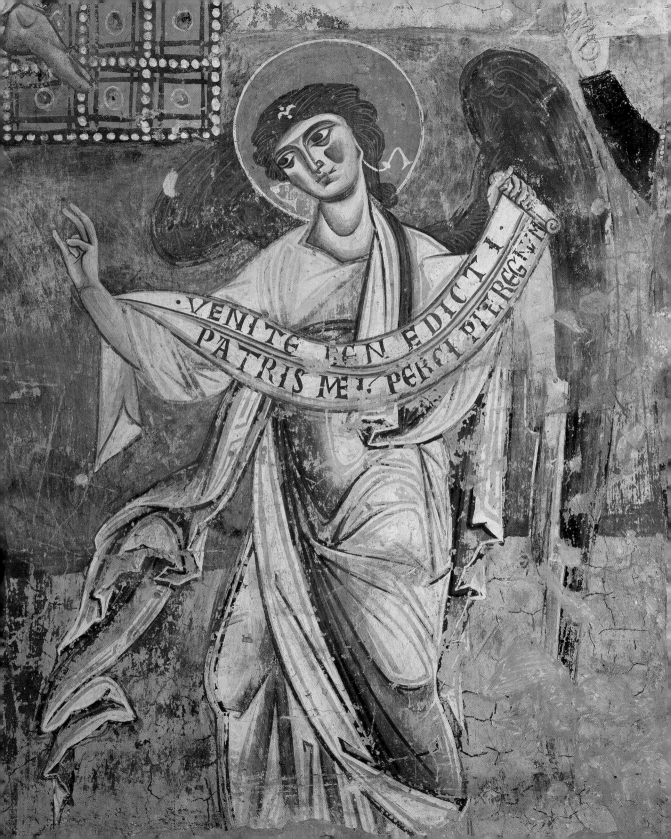

VENITE BENEDICTI PATRIS MEI PERCIPERE REGNUM

Majestas Domini and Heavenly Jerusalem

Ceiling fresco
Saint-Chef (Isère), Abbey Church of Notre-Dame, Chapelle Conventuelle

The apses and convent chapel on the upper level of the northern transept of the abbey church of Saint-Chef (east of Lyon), converted in 1056, contain remnants of what was surely once extensive fresco work. The paintings in the chapel, consecrated to St. Michael and St. George, were freed of later painting in 1967, and, though damaged, are in a quite good state of preservation. In the small apse niche, the eye falls on a depiction of Christ in his glory, surrounded by angels and the symbols of the Evangelists. Three of the archangels, and the knight St. George, have heads modelled in stucco. The figure of Christ, majestically seated on a cushion-covered bench in the oval of the aureole, is found again at the apex of the high, four-sided vaulting – at the focal point of an enormous panorama of the Heavenly Jerusalem, populated by the typical figures in this eschatological motif: the Virgin, Apostles, angels, saints, all of them in the midst of the rectangular plan of the temple.

Above the haloed head of Christ we see the Lamb of God, but as if reversed because already belonging to another segment of the vaulting, its spherically tapered narrow side is visible. There it forms the culmination point on the gate of the heavenly temple. Arrayed around the aureole are the members of the divine retinue. It is symbolically significant that the gate, the lamb, the Majestas Domini, the book of life open in Christ's lap, and finally the Virgin, are all arranged along the central axis, whose continuation virtually extends down to the apse of the chapel, where it impinges upon a second Lamb of God and a further Majestas in the cap of the apse. Comparable twinnings, if distributed on different spatial levels, are by no means unusual in medieval pictorial programs.

The painted firmament replies iconographically to the actual architecture, on which, figuratively speaking, it rests with the aid of artistic visualization. At the borderline between the two spheres of reality stand the Evangelists, the prophets, and the Apostles, as well as – engrossed in discussion – the twenty-four eldest of the Revelation and the four church fathers. The word of God, as the painted surfaces of the vaults ensure the faithful, will be received and "supported" by the heavenly hosts, and its message disseminated by the Evangelists to the four corners of the earth. Finally, chronologically speaking, it will be interpreted and taught by the church fathers. To cite Ehrenfried Kluckert: "The chapel architecture is merely a vehicle for the story in pictures, which defines it as 'heavenly architecture'. The Chapelle Conventuelle in Saint-Chef is among the few Romanesque fresco programs to have survived so completely."

The relatively early date of the Saint-Chef frescoes, apparently confirmed by a paleographic determination of an inscription below the apse window, explains their many stylistic reliances on Ottonian – or, to use a more neutral term – on pre-Romanesque art. Despite these retrospective traits these remarkable paintings are characterized to a much greater extent by anticipations of a truly Romanesque style – especially as regards the architectural treatment of the composition and the monumentalization of individual forms.

> "The church [building] shines within its walls and in its arms it suffers want! It clads its stones in gold, and leaves its children to go naked! With the offerings of the needy, the eyes of the rich are served. The curious come to take pleasure, and not the miserable come that they be nourished ..."
>
> Bernard of Clairvaux, c. 1124

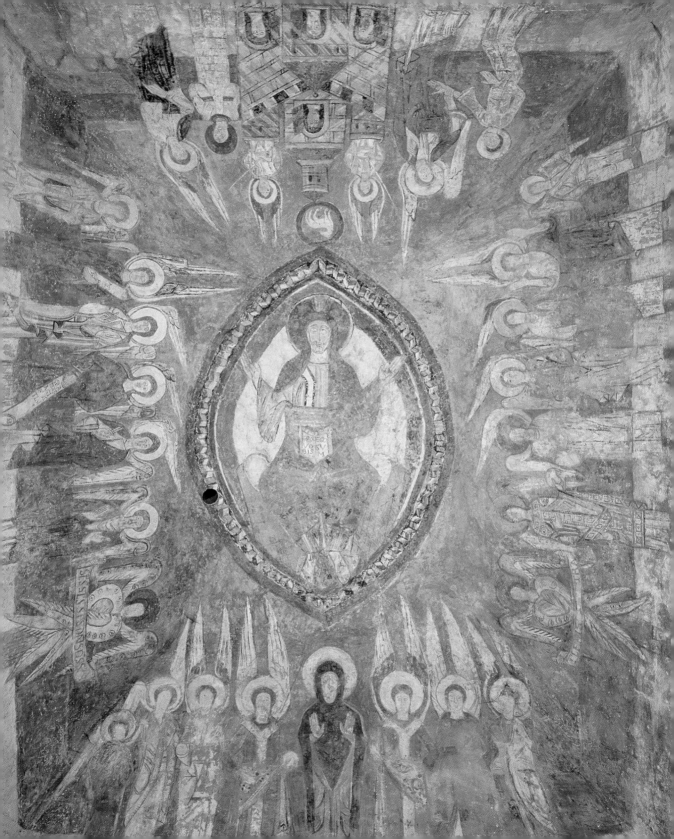

The End of King Herod

Mural (fresco with secco applications)
Lambach (Austria), Benedictine Church, west gallery

The extensive fresco cycle in the Lambach Benedictine monastery church is in a wonderful state of preservation. The church was built from 1056 to 1089, at the instigation of Bishop Adalbero of Würzburg, from the house of the dukes of Lambach-Wels. The depictions of the childhood and adolescence of Christ in the west choir and gallery likely formerly continued in a Christological cycle in the nave and in the yet to be investigated east choir.

A total of twenty-three scenes and remnants of scenes, and four individual Old Testament figures, are currently visible. Stylistically, two fundamental elements can be identified: late Ottonian manuscript illumination in Salzburg, and the Byzantine-inspired art of Upper Italy. By whatever means of communication, the workshop, likely located in Salzburg, must have become familiar with frescoes like those of Concordia Sagittaria in Veneto, but especially with the mosaics in the vestibule of San Marco in Venice. Art historians assume that at least the chief master was schooled in one of the centers of Byzantine art export, in Aquileia or Venice. Accordingly, the ornamental components, too, ultimately derived from the antique tradition, disseminated through Byzantine waystations.

The wall frescoes in Lambach were not rediscovered until 1956. They are considered to be the oldest surviving examples of this particular genre in Austria, and count among the most significant creations in Western art. Their program is so unique that the interpretation of many of their details has proven very difficult. One thing, however, is beyond a doubt – their anti-imperial content.

Bishop Adalbero was a radical follower of Pope Gregor VII,

German imperial crown,
circlet c. 962, arch and
band c. 1027

the greatest opponent of Emperor Henry IV, who promptly expelled Adalbero from his home bishopric of Würzburg. The pontifex fled to his family's ancestral castle and immediately gathered reformist monks around him in a newly established chapter. The tendentious content of the frescoes likely goes back to Adalbero.

This thrust is most obvious in the Herod scenes. The very vividness with which this criminal Jewish king is depicted implies a "critique of tyranny", as Robert Suckale has said. The scene illustrated here represents his imminent end, which was preceded by a suicide attempt. Discarded on the table lie the king's crown and armlet, and three demons lurk phantomlike near the palace walls. Indicatively, an adjacent picture shows Herod's dismay at the announcement of the birth of the King of the Jews. Overcome by this terrifying vision, he falls to the ground like some crushed insect. Showing a ruler so helpless, and at the same time so demonic, was an absolute first in the history of medieval art. And the message is unmistakable, because the artist has adapted the figure of Herod still seated on his throne at the left to the image of Henry IV as seen on his privy seal. The hoop crown worn by the Old Testament regent, and the globe divided into the then-known three continents he is holding, were insignia reserved solely for the emperor of the Holy Roman Empire. Every viewer of the fresco must have realized this parallel.

The Lambach fresco painters adopted the "true" fresco technique from Italy, where as early as the Romanesque period colors were occasionally applied to the fresh plaster, which with they entered a durable chemical union. Blue and gold, however, were not suited to the fresco technique, so they were applied to the dry wall "al secco" and therefore faded or crumbled in the course of time. The manner of underpainting and interior hatching conforms with Byzantine practices.

Noah's Ark

Mural (fresco)
Saint-Savin-sur-Gartempe, Abbey Church, vault

The fresco illustrated here belongs to a Noah cycle related in eight episodes, in the context of an Old Testament series extending over the vault of the former Benedictine monastery church. Beginning with the story of Creation and the Fall from Grace, continuing through Cain and Abel, Noah, and the Tower of Babel, to the history of Abraham, Joseph, and the life of Moses, the Old Testament section of the program – more precisely, the period "ante legem", before the Tablets of the Law were given to Moses – comes to a close. A New Testament sequence adorns the presbytery and galleries, and further frescoes are found in the vestibule (Apocalyptic themes) and the crypt. Perhaps a transept cycle also once existed.

The superb series of paintings in the barrel vaulting were executed in one session by at least four artists. The remaining groups of works were apparently the responsibility of a single, leading artist in each case. The fresco painter who executed the paintings at eye level presumably originated from the atelier of Sainte-Radegonde in Poitiers, known principally for book illumination, whereas the painters of the nave and west gallery were surely specialists for large-scale formats. In view of this division of labor, Saint-Savin evinces a skilled variation of visual language depending on the format of the areas to be painted and their conditions of viewing, i.e. the viewer's vantage point in each case.

The strangely abrupt leaps in the narrative flow of the Old Testament scenes in the nave vaults are explained by the fact that the artists painted sections of vaulting as soon as the builders

View of the nave of St-Savin-sur-Gartempe

had finished them. The decoration must have been made at a rapid pace, probably beginning in the west gallery and continuing through the transept to the choir and crypt.

Stylistic criticism has emphasized the consistent way in which the garments are rendered. They are frequently gathered at the knees into an "hourglass" shape, then fan out below. Other characteristic traits are the figures' mincing gait and frequently crossed legs; their pathos-filled gestures of great expressive power; and finally, a basic tendency to avoid Byzantine tendencies and the associated hieratic stringency of figures in favor of a greater narrative flow that is well embodied in their vivid actions. It is no exaggeration to describe the Saint-Savin frescoes as the greatest possible contrast to those in Berzé-la-Ville (ill. p. 55).

The protagonists in each scene move along baselines in front of the plane, although overlappings and superimpositions do suggest a shallow space. This also holds for the view of Noah's Ark, a bellied ship with a prow carved in the shape of an animal's head. In accordance with the biblical story, the ark has a three-tiered superstructure with round-arched windows, behind which some of the the rescued animals and Noah's family are visible.

In sum, the superbly preserved ensemble in Saint-Savin forms the most extensive and both artistically and iconographically most fascinating specimen of Romanesque mural painting in France – an outstanding masterpiece even by comparison to other European painting of the period. The complete story of Christian redemption from the beginning to the end of times is represented in the frescoes, and it ennobles their vehicle, the church building, to an "ecclesia", a congregation of the church in the spiritual and symbolic sense.

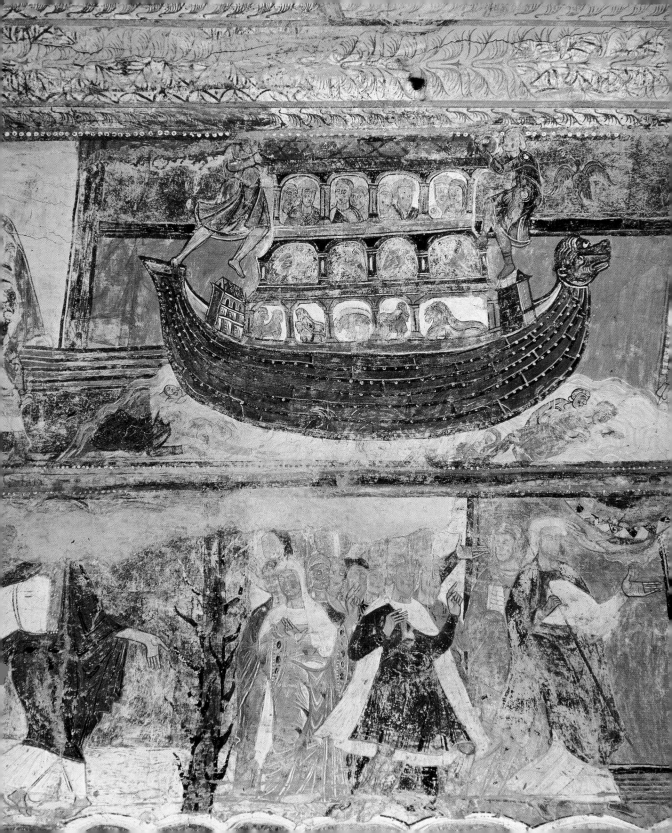

The Fight with the Dragon

Mural (fresco – with secco additions?)
San Pietro al Monte, near Civate at Lake Como

Tracing the transmission of antique forms from many sources and on many overlapping levels is one of the fundamental problems in the history of Romanesque painting in Italy. This stylistic transfer had three key points of departure: Roman classical heathen antiquity proper; the period of late antiquity and early Christianity – two sources that played a significantly greater role in this region than in the rest of Europe – and finally, their transformation as a consequence of particular influences from Byzantine art. What entered Italian art through these components were relatively well-formed, expressively agitated figures, remnants of a capability of imagining space, and the knowledge of means of depiction that had been lost to the Middle Ages: light and shade, foreshortening and perspective. Many of these elements are manifested in a chef d'œuvre of the epoch, the murals in San Pietro al Monte in Lombardy, on the slopes of Monte Pedale overlooking Lake Como.

The dating of the wall and vault frescoes is problematic. Some scholars place them at the end of the eleventh, others in the first decades of the twelfth century – a dating to the years around 1100 would seem most plausible. The program, among the most suberb decorations in early Romanesque painting, combines Ottonian elements with remnants of an ancient Roman illusionism, Byzantine formulae of the kind seen in part in the apses of San Marco in Venice and San Giusto in Triest, and clearly Romanesque compositional principles. Its grand visions of Heavenly Jerusalem and the apocalyptic battle with the dragon raise these frescoes high above other imagery of the day.

Evidently five different artists or workshops were involved in the decoration of the former Benedictine monastery church, rebuilt in the mid-eleventh century. The most outstanding contribution is that of the master who created the painterly, illusionistic paradisal landscape in the eastern field of the vault, which reflects a close study of ancient models. God the Father is enthroned with the book of life on his lap and the lamb at his feet, in his right hand the golden surveying rod with which he has laid out the city, in the midst of the Garden of Eden encompassed by turreted walls with twelve gates. The foliage in particular is rendered in a well-nigh impressionistic, late antique manner. Of even greater quality is the arcaded arch image on the east wall of the vestibule, from the hand of the anonymous "Master of the Fight with the Dragon". He was one of the most outstanding artists of the period, not only in terms of imagination but of technique, having employed a highly advanced paint application of several layers of glaze. This master may well have also been responsible for the design of the decorations as a whole.

The twelfth chapter of the Apocalypse describes the battle of the angels under their leader Michael against the seven-headed dragon that threatens the apocalyptic wife and her newborn, followed by the spiriting of the child to heaven. This rendering of the events in San Pietro has a hieratic force combined with a masterful dramaturgy that make it one of the most compelling creations in all of Western art.

Milanese monumental painting, manifested at its best in San Pietro, is also found in Civate proper (San Calogero) and, in provincial shadings, in Tessin. Influences of this style even spread as far as Catalonia.

The fight with the dragon, mural painting
in San Pietro al Monte, general view

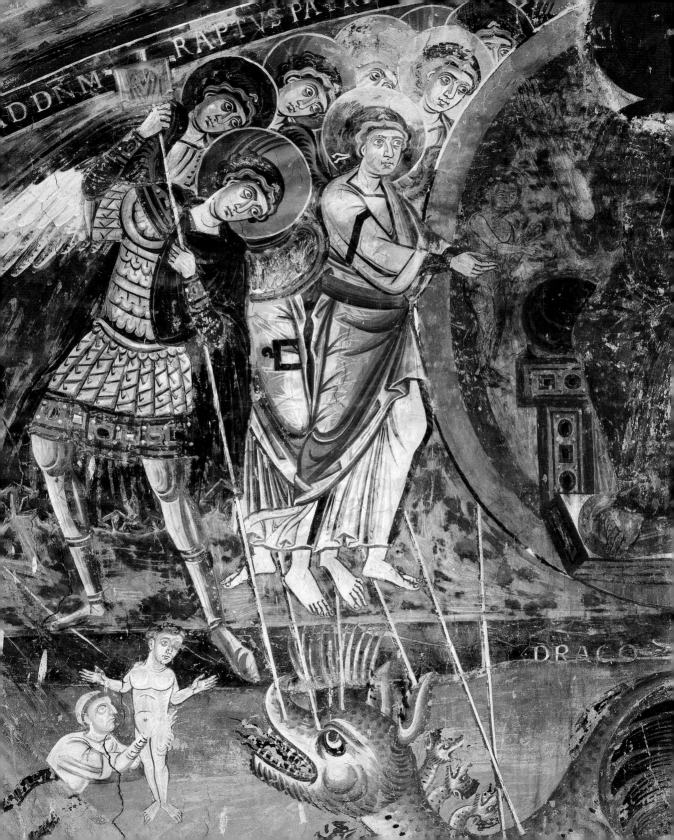

christ and the Twelve Apostles

Antependium from La Seo de Urgel, panel painting (tempera), 130 x 150 cm
Barcelona, Museu Nacional d'Art de Catalunya

The once surely extensive stocks of European panel painting of the Romanesque period shrank drastically over the course of the centuries. Most of what remains is now found in churches and museums in Italy and Spain. Only a few of the paintings on wood done in Spain can be classified as retables – more or less tall panels located above altars. Far more served as antependia, painted screens mounted on the side of the altar facing the congregation. Painted antependia were a sort of surrogate for much more costly pieces in silver or gilded copper. Stylistically, very close reciprocal effects obtained between panel paintings and concurrent murals in each region.

Accordingly, the artistically superb antependium from La Seo de Urgel, one of the earliest specimens of Spanish panel painting, shows great analogies with a number of examples of fresco art found in the same place (San Pedro). Depicted in the horizontal rectangle, divided in the manner of a triptych, is Christ Pantocrator between pyramidally composed groups of Apostles, headed by St. Peter and St. Paul. The dating of the work is no more than vague, stylistic considerations being the only pointer to placing it at the turn of the eleventh to the twelfth century.

The conception of the whole is impressive, its intrinsic grandeur – especially as regards the expressive power of the Pantocrator figure – being paired with a monumentality worthy of a wall or ceiling fresco. Heavy contours combined with strictly linear stylization and parallelism of interior drawing constitute a formal language of compelling effectiveness. The panel is a masterwork not least on account of its sonorous and at the same time highly sensitive disposition of colors. The way the surface of the middle section shines out behind the figure of Christ in intense red; the way the aureole around the Pantocrator, composed of two ovals and ornamentally framed, sets a contrast of warm, subdued yellow-orange; the way the Apostle group is set off from a background of nearly the same hue, while the colors of their garments harmonize with those of the Pantocrator despite differences in detail – all of this attests to outstanding artistic skill.

In the German-speaking region about two dozen examples of panel painting have survived: retables, antependia, a few crucifixes, icons, painted reliquaries, and sacristy cabinets. Naturally one must mention two quite singular works among these: the painted wooden ceilings of Zillis and of St. Michael in Hildesheim. It is usually quite difficult to say whether the early works that served as altar decorations were antependia or retables. Doubts of this kind also hold for the earliest surviving example of German panel painting, the panel from the Augustinian convent church of St. Walpurgis in Soest, dating from c. 1170, which is now harbored in the Landesmuseum, Münster. At the center of this horizontal format, formerly framed by inlaid ornamental reliefs, appears the Apocalyptic Christ, flanked on the left by Walpurgis and Mary with the seven doves of the holy spirit (an unusual motif), and on the right by John the Baptist and St. Anthony.

Master of Soest, antependium from St. Walpurgis Convent, Soest, c. 1170

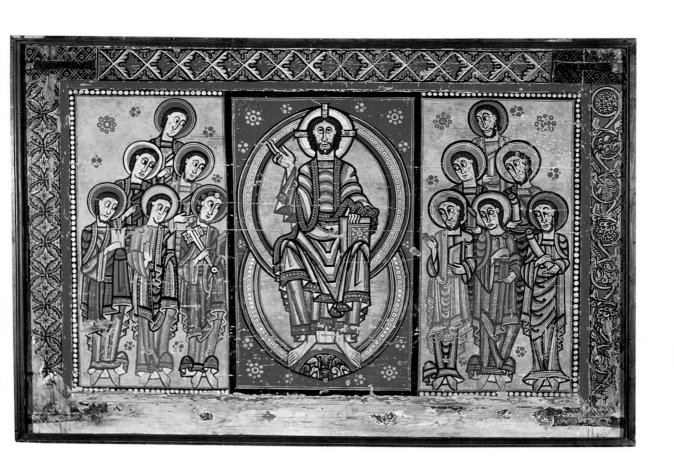

тhe мiraculous Rescue of a child from the sea of Azof by st. clemens

Mural (fresco with secco applications)
Rome, San Clemente, lower church

Apart from the evocation of early Christian models, on which almost all painting in the city of Rome was based, and apart from the continually appearing Byzantine elements, sometimes combined with southern Italian influences, it was ultimately the local factor of antiquity that determined the character of Romanesque painting in Rome more strongly than anywhere else. This stylistic amalgam was pervaded by a "neoclassical" tenor, especially in the field of decoration and ornament. It determined textile patterns, filled with very lively and naturalistic birds, and it dominated the framing panels with their long-stemmed plants growing from candelabra and elegantly intertwined leafwork.

The style evidently took on its classical form under Pope Paschal II (1106–1118). The most significant examples are the murals in the lower church of San Clemente. The earliest of those in the quite dark room go back as far as the early Christian period, the fourth century A.D. In the early twelfth century, as the building and furnishing of a modern upper church were underway, the old basilica which had since become the lower church already lay five meters below street level (it was not rediscovered until 1857, in the course of excavations).

The Translation of the Relics of St. Clemens, c. 1100

One of the scenes on the walls, that of the reliquary translation, is characterized by a lucid articulation of the plane and a straightforward narrative style, elegant lineature, and a sonorous coloration. In terms of content, the depiction refers to a legendary event, only partially bolstered by historical facts. In the ninth century, the story goes, the Slavic apostles Kyrill and Method transfered the relics of Pope Clemens, who had been banned in about the year 100 under Emperor Trajan to Crimea and had suffered a martyr's death there, to old St. Peter's Church in Rome. In 868 the bones then passed from there to the basilica which had long since been consecrated to Clemens.

The hand of another artist, whose style is marked by unusual contours, shining highlights, and especially decorative arrangements, is seen in the mural of the miraculous rescue of a child from the Sea of Azof. From the depths where the pope's body had been submerged, the legend goes, a marble chapel had arisen. Once a year the masses of water receded, making the chapel accessible to pilgrims. One day a mother lost her small child there, but found him again the next year, unhurt. Below this scene we see a medallion portrait of Clemens, flanked by donor figures.

The legend is related with naive simplicity. The unity of the image rests less on spatial consistency, although this is occasionally present, than on the rhythm of forms and colors that spreads uniformly across the plane, and on the elegant flow of lines. The complex coloration with its effectively placed highlights recalls Byzantine work – not so much mosaics as book illuminations. The most closely related of these are the miniatures of the Roman scriptorium of Santa Cecilia in Trastevere, whose influence began to make itself felt even before Montecassino. Here, after a long intermission, ancient Roman art was "discovered". This is evident not only in the forms of the ornament and framing, but even more so in the treatment of the image itself as a sort of proscenium stage with architectural backdrops. The arrangement of the figures, their massing into groups and crowds, likewise calls late Roman art to mind.

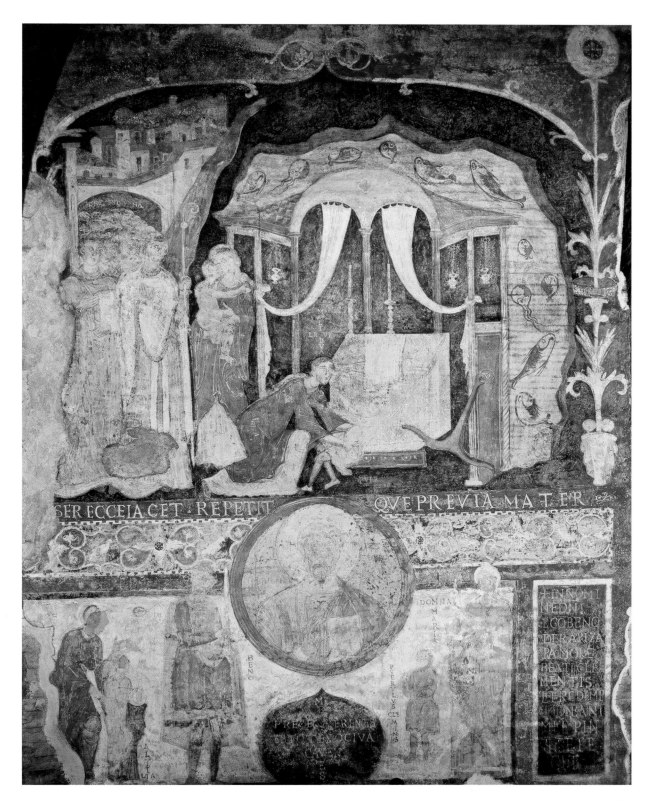

SER ECCE IACET · REPETIT QVE PREVIA MATER

Baptismal Font

Cast bronze, height 60 cm, diameter 80 cm
Liège, Saint-Barthélemy

According to a contemporaneous source, the donor of this marvelous work was Abbot Hellin (1107–1118), who ordered it for the church of Notre-Dame-aux-Fonts in Liège, from a certain "Aurifaber Renerus", the goldsmith Reiner of Huy. Since 1803 the cylindrical baptismal font has been in Saint-Barthélemy (the pedestal is of more recent date and was originally runner-shaped).

With this object, the fledgling field of Romanesque metalwork suddenly reached an apex. The font provided impulses for the twelfth century, all the way down to the works of Nicolas of Verdun (see p. 84/85). Thanks to its outstanding technical and artistic quality, art historians have come to view the piece as one of the most prominent paradigms of the Maas School, which due to the rich ore deposits near Dinant specialized in bronze works (and their export).

Five scenes, compositionally linked by a base wave and separated by trees, encompass the walls of the font. The subject matter, likely inspired by Byzantine iconographic models, ranges from the baptism of Christ in the Jordan through the baptism of Cornelius by St. Peter and the legendary baptism of the philosopher Crato by St. John the Evangelist, down to the preaching of John the Baptist in the wilderness to St. John's baptism of the publicans in the Jordan. Based on the type of the "Brazen Sea" – a font of solid bronze recorded in the Old Testament as having served the ritual ablutions of the priests in the Temple of Solomon in Jerusalem – the font rests on ten (formerly twelve) cattle

Bronze baptismal font from Hildesheim Cathedral, c. 1225–1230

symbolizing the Apostles in medieval theology. The lid, destroyed during the French Revolution, was adorned with figures of prophets and apostles.

The figures in the relief are almost three-dimensionally modelled but nevertheless appear solidly tied to the ground – recalling an ancient Greco-Roman device, as does the daring figure seen from the back. The relief ground makes no attempt at suggesting depth, the artist having concentrated solely on the figures' drapery and softly modelled bodies. The definitely classical air of the work lends it an exceptional place within Romanesque art.

The four most-renowned names in Maas School sculpture from the Romanesque and late Romanesque period are, in the chronological order of their appearance, the present Reiner of Huy, then Godefroid of Huy – better known as Godefroid de Claire – Nicolas of Verdun, and Hugo d'Oignies. All of them were laymen, but were familiar with the theological culture of the period less as artisans than as poets.

The "Master G" with whom Abbot Wibald of Stablo (Stavelot), one of the leading churchmen of his time, corresponded, may well have been identical with Godefroid of Huy. At any rate, in 1148 the abbot requested a work from this virtuoso of bronze casting, flattering him in a way that anticipated the patron-artist relationship of the Renaissance.

The recognition accorded to the outstanding goldsmiths and bronze founders of the period was surely the main reason why their names were relatively frequently passed down. This is sadly not the case with the creator of the bronze baptismal font in Hildesheim Cathedral. However, it does indicate that Lower Saxony too was a domain of high-medieval metalwork, where the Romanesque tradition remained present far down into the thirteenth century, until the rise of the new, Gothic sense of form.

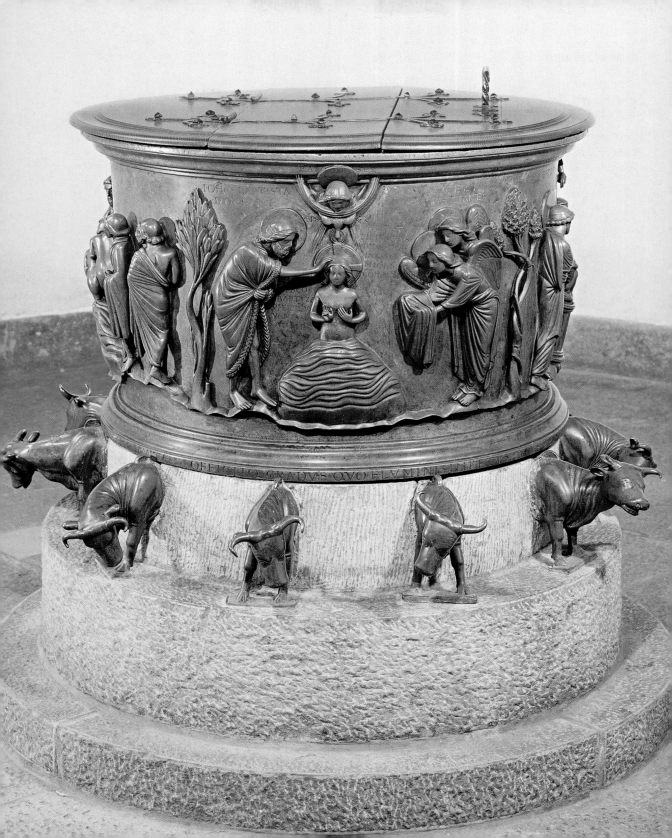

тhe cross of Life

Mosaic
Rome, San Clemente, apse of upper church

Near the Colosseum in Rome, on the street that gradually leads uphill to San Giovanni in Laterano, lies a basilica bearing the name of the canonized Pope Clemens I, the third successor to the Holy See (regarding the lower church, see ill. p. 43).

The fourth-century building was largely destroyed by the Normans in 1084. During an especially heated phase of the Investiture Controversy, when investiture was again banned in 1110, Pope Paschal II ordered the church to be rebuilt over the buried remnants of the old basilica. Like an invocation of venerable ecclesiastical power directed against the upstart empire, the rich furnishings of the church reflected the formal repertoire of early Christian churches. In fact, many of the erstwhile furnishings – especially objects added in the fifth and sixth centuries – were purposely integrated in the new project.

One of the new works, outshining all the rest, likewise calls up associations is dominated by the cross. Its phenomenal gleaming blue recalls the art of "email", or baked enamel. Mary and John flank the upright of the cross, at whose foot emerge the four rivers of paradise. There deer are drinking, and we also see a phoenix, the legendary bird that symbolizes immortality. Twelve white doves embodying the Apostles perch on the joist and crossbeam. Behind the emblem of the cross a number of relics, including an actual particle of the crucifix, are embedded in the wall. The mosaic thus serves the purpose of a "staurothek", a crucifix reliquary. Above the cross opens a vision of the starry firmament from which the hand of God reaches down in a gesture of benediction.

The plant ornament filling the cap of the apse, with lovely, twining acanthus tendrils, refers to Eden and defines the cross as the "Tree of Life". At the same time, the flourishing tendrils around the martyr's cross provide life and nourishment to men and women from all walks of life, indeed to every living creature. In the midst of the figures we notice four clad in plain black and white. These embody the Latin church teachers and saints Augustine, Hieronymus (Jerome), Gregor, and Ambrosius.

The lower, bordering frieze with the Apocalyptic Lamb once again refers to the Heavenly Jerusalem. The visualized cosmos of redemption includes church history as well, in the form of a meeting on the triumphal arch of Peter and Clemens, Paul and Lawrence, and the prophets Jeremiah and Isaiah. The program, in sum, idealizes the pope actually enthroned below in the apse, symbolizing the universal power of the Catholic church.

It is no coincidence that this maxim is expressed stylistically in terms of venerable models. The artists who created it looked back to the "impressionism" of urban Roman mosaics of the fourth and fifth centuries, in Santa Pudenziana or San Maria Maggiore. As there, they accentuated the incarnadine and the folds of the garments with strips of white tesserae bounded by black and gray – precisely along the lines of ancient Roman techniques.

Even genre scenes long existed in the mosaics in early Christian sacred spaces. These all reappear in San Clemente, enriched by waterbirds, as formerly depicted along the edge of the cupola of Santa Costanza, and by scattered vine leaves, bunches of grapes, and frolicking infant angels.

"мore than eagles has the sign of the cross, more / than caesar has рeter, / more than all leaders has the unarmed people affected me."

Hildebert of Lavardin, in a poem in which he lends the city of Rome a voice, c. 1106

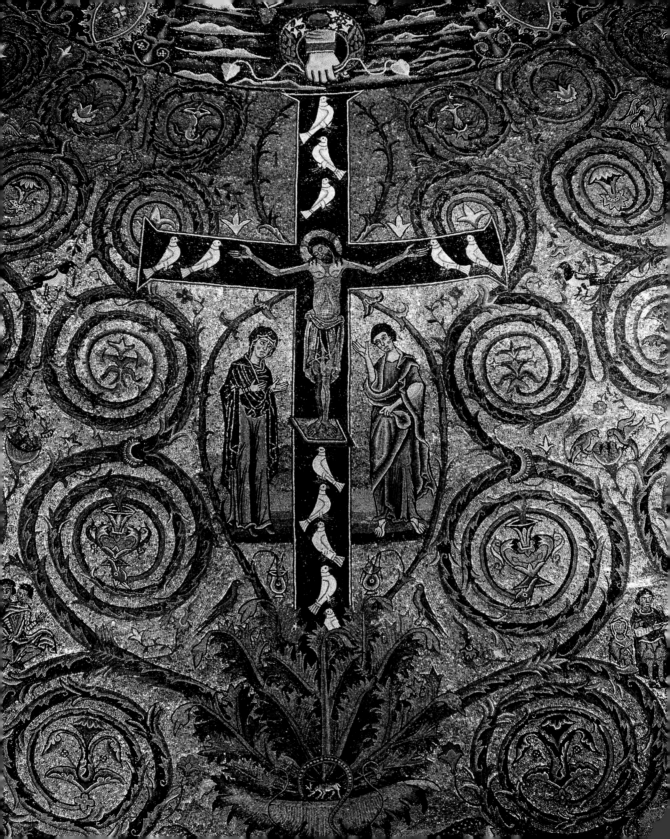

Majestas Domini with Evangelists and saints

Mural (fresco with secco applications), overall height to apex of apse c. 5 m
Barcelona, Museu Nacional d'Art de Catalunya (formerly San Clemente de Tahull, Catalonia)

Based on a consecrational inscription, these frescoes can be dated quite precisely. Their remnants were removed from the church walls and are now harbored in the Museu Nacional d'Art de Catalunya. Two artists were involved in their execution: the superb Master of San Clemente, who created the decoration in the main apse, and the "Master of the Day of Judgement", who painted parts of the triumphal arch, the side apses, and probably also the walls and pillars in the nave, and whose work is also found in Santa María de Tahull (ill. p. 51).

The art of the principal master is characterized by monumentality, uncompromising geometric arrangement, and brilliant, luminous colors. The apse fresco in particular is the most powerful achievement of Romanesque fresco painting in Catalonia, indeed in all of Spain. In fact one is justified in calling it an outstanding work in European art of this era as a whole.

In the middle apse of San Clemente, a key theme of high Romanesque art, the Majestas Domini, found one of its most glorious expressions. Christ is surrounded by the four symbols of the Evangelists, angels and cherubim. The general impression is one of grandeur, and a visual magic never again matched in Spanish art of this era. The details are no less important than the composition as a whole. Each individual button, each figure is like a spiritual epiphany. The angel with the eagle, symbol of St. John, is no less delightful than the angel who embodies St. Matthew.

But it is the monumental, awesome figure of Christ that truly transfixes the viewer. The omnipotent ruler is surrounded by a highly-charged rainbow aureole, and is seated on a second rainbow that symbolizes the new heaven and the new earth. His right hand, strikingly breaking through the aureole, is raised in a gesture of dominion and blessing. The fascination of the divine face, the superhuman appearance of his head, is underscored by exaggeratedly elongated proportions. Could the declaration in the open book, EGO SUM LUX MUNDI (I am the Light of the World), find any more compelling and moving visual form than this?

Depicted in the painted arcade zone below the Majestas, and thus below the conchas (the half-domes covering the apse), is an "Apostalado" with five figures of Apostles: St. Thomas, St. Bartholomew, St. John, St. James and St. Philip (?), accompanied by the Mother of God. As expressively alienated as the remaining figures, in her veiled left hand she raises a bowl filled with the mysteriously gleaming red blood of Christ – a depiction of the Holy Grail that, as Otto Demus noted, recalls that Catalonia was a center of grail worship in the Romanesque period. In addition, Mary and St. John stand closest to the enthroned Christ above their heads, just as in depictions of the Crucifixion – an allusion to Golgotha and the cross as an "instrument" of redemption. The New Jerusalem, the apse decoration tells us, rests on the Apostles and Mary who stand between the columned arcades. And at the original site, this vision appeared behind and over the altar at which each celebration of the communion offered the promise of salvation to the faithful.

The chief master in Tahull, who possibly came there from Aragon, also created the daringly simplified hand of God and the seven-eyed lamb in the reveal of the triumphal arch, and the painting on its wall, only remnants of which have survived. The greatest influence on his art apparently came from France, from the art of Toulouse, Languedoc, and Provence.

"I do set my bow in the cloud, and it shall be for a token of a covenant between me and the earth."

Book of Genesis, 9:13

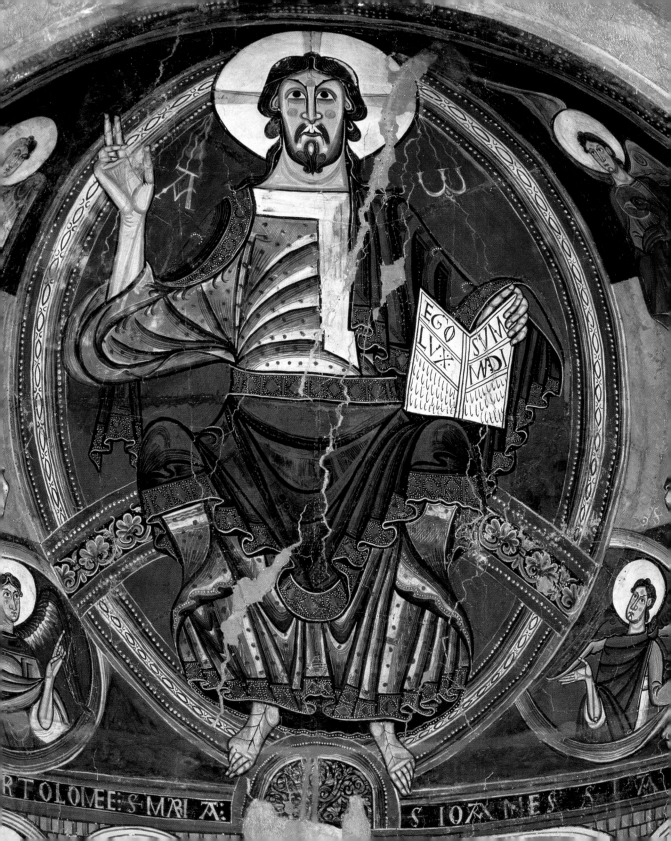

EGO
LVX
SVM
MDI

S BARTOLOMEVS MARIA S IOANNES

The Madonna Enthroned

Fresco with secco applications, detail approx. 2 x 1.45 m
Barcelona, Museu Nacional d'Art de Catalunya (formerly in the apse of Santa María de Tahull, Catalonia)

Santa María de Tahull was the sister church of San Clemente – in the same Catalonian town and likewise consecrated in 1123 by Bishop Raimundus of Barbastro. However, its main nave contained a depiction (before its transfer to Barcelona) not of the Majestas Domini but of the Mother of God, enthroned between the three adoring Magi.

Byzantine art developed several chief types of Madonna, in which the virtues and redemptive qualities of the Virgin and Mother of God, described in the St. Mary litany, came out explicitly or in encoded form. Two of these formulae in particular spread throughout the Christian West: the "hodegetria", or "guide to the way", and the "nikopoia", or "bringer of victory". In the hodegetria, the Child is usually seated on the Madonna's left knee or arm, whereas the nikopoia takes the form of a stringently symmetrical composition, with the Child seated in the center, as if himself enthroned in his enthroned mother's lap.

The various epochs of sacred art favored different types of depictions of Mary. The Romanesque definitely favored the stringent, nobly enthroned nikopoia – as for example in the case of the painter of the Virgin of Tahull.

Not so much appealing to the empathy of the faithful as embodying the unapproachable Queen of Heaven, the Madonna sits on an ivory throne, the symbol of her wisdom and purity – hovering above the altar before the eyes of the congregation as the "sedes sapientiae", or seat of wisdom. As such, she can be compared to the bride of Solomon from the Song of Songs or with the "ecclesia", the institution of the church. Over a red gown she wears a blue mantle, its lower part draped in an almond shape with three folds around Christ. Her feet rest on a gem-studded stool, the emblem of royal highness.

Christ is not depicted as an infant (let alone a naked one, as in later centuries). Rather, he is presented in his full glory as "King of Kings". As in the context of Pantocrator images, Christ is teacher, giver of blessings, and judge in one. The manuscript scroll in his hand illustrates his capacity of "the true wisdom of the world". Also like a Pantocrator, Mary is encompassed by a rainbow aureole. This motif may also characterize her as a "porta coeli", or gateway to heaven, as which she is widely praised in the hymnic literature. But she is not entirely beyond this world, for the green color in the aureole, which is not completely closed, and the green band in the background symbolize her role as mediator, indicating that through Mary, God descended to the earth and became flesh. The same thought is conveyed by the three Magi, to whom – and through whom the world – was revealed the newborn King of Heaven and Son of Man in the manger of Bethlehem.

This treatment of the subject, one of the most beautiful of its kind in all Romanesque art, stems from the hand of a master whose lucid rendering of the rounded limbs, relative faithfulness to anatomy, energetically delineated curvatures and sweeping lines reflect a formal language then unprecedented in Catalonian mural painting. Its source can be quite clearly located: the art of the chief master of San Clemente, who was concurrently active in Tahull (ill. p. 49). This cannot be said of a second painter who worked in Santa María, the "Master of the Last Judgement", who completed the frescoes with a cycle on the nave walls and in the transepts.

Archangel Michael with the scales of justice, detail from the Last Judgement, c. 1123

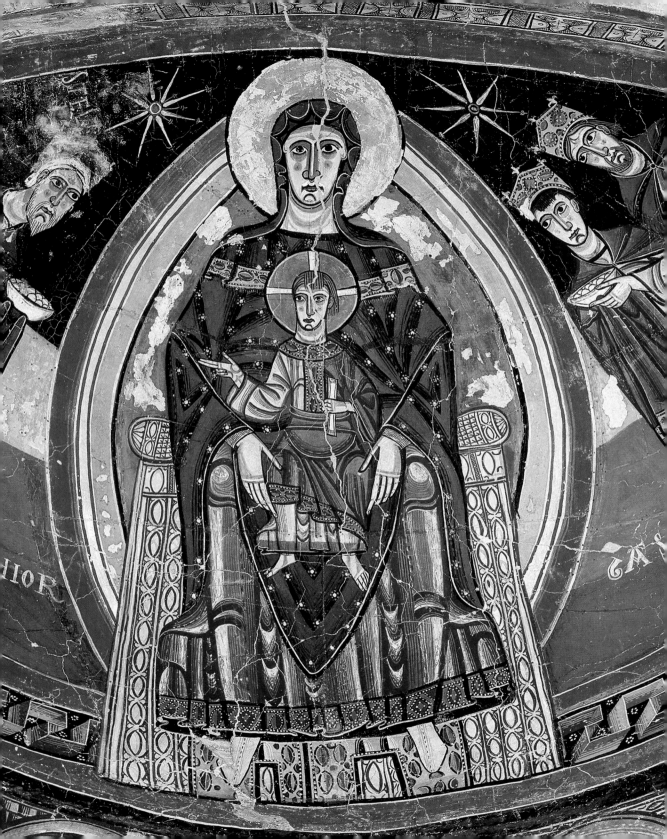

тhe рrophet ısaiah

Stone relief, height 176 cm
Interior west wall of the former abbey church of Sainte-Marie in Souillac

==

The relief sculptures of the former abbey church of Sainte-Marie in Souillac (Lot) are among the aesthetically most remarkable achievements of Romanesque sculpture and architectural sculpture, which were especially impressive in France. The figure of the Old Testament prophet Isaiah towers above the rest with an unforgettable expressive power. Originally it was probably located on the right-hand portal pillar, belonging with other sculptures of varying quality to an extensive portal group that was evidently considerably damaged during the Huguenot Wars and whose fragments were later rearranged.

The figure of the prophet – perhaps depicted at the moment Isaiah was called by God – is divided into separate compartments that, like nodes of energy, radiate a seemingly untamed yet compositionally controlled dynamism in various directions. Note the separate locks of hair and beard, which take on an almost animal life of their own, organic configurations swarming around the prophet's face as he looks out at the viewer. A sculptural depiction of the prophet Jeremiah in Moissac inspired the anonymous sculptor of Souillac, yet he infused this "model" with extreme dynamism and translated its standing motif into a kind of striding one. Every gesture, every movement, and the ornamental lineatures as a whole, convey a visionary ecstasy. Head, hair, halo, collar, and shoulders are conceived in frontal symmetry. At the same time, the figure turns on his own axis, his right arm holding the scripture scroll as an instrument of prophecy, no longer beholding to the will of man but obeying a superior divine power. This element is purposely isolated and emphasized as an unreal or supernatural phenomenon.

The figure of Isaiah, pulsating with powerful plastic life, embodies a maximum of what Romanesque art was capable of producing in high relief. Still, the lineatures and the flattening of the foremost passages engender a layer that is not penetrated by the figure and mitigates the impression of fully rounded form. Sculptural form remains caught between two parallel layers, that of the ground and that of the foremost surface – this, too, a typical stylistic principle. The ample mantle with its richly decorated hem almost completely fills the relief ground, even in places entirely merging with it – an integration that represents an innovative sculptural approach.

A further outstanding example of the architectural sculpture of this once so important abbey church is the stone "trumeau", or middle pillar, of the lost portal, one side of which is adorned with intertwined, fighting animals. One of the beasts is in the process of devouring a man. The artist – the question of whether it was the same one who carved the Isaiah must remain open – succeeded in capturing the tumultuous wildness of the moment with its evocatively demonic effect while at the same time taming it by means of symmetrical arrangement. Chaos and order stand opposed like two sides of a coin – a contrast frequently met with in Romanesque art.

In sum, the various sculpture groups in Souillac undoubtedly represent superb achievements. The depiction of the prophet, in particular, is the most significant of its kind in all Romanesque art.

Middle pillar, now on the interior west wall in the church in Souillac, c. 1120–1135

christ in his glory

Mural (mixed techniques), height approx. 4 m
Berzé-la-Ville, chapel of the Château des Moines, apse

The most significant frescoes in Burgundy are those in the chapel of the Château des Moines in Berzé-la-Ville, reportedly the place where the contractor, Abbot Hugo or Hugues of Cluny (1049 – 1109), retired in order to meditate in solitude on the "last things". The remnants of the late-twelfth-century frescoes in the nave are related in a way with the art of regions north of the Loire, whereas the far finer apse decorations stand practically alone in terms of technique, palette, iconography, and style, not only in France but in European Romanesque mural painting as a whole. Certain parallels are found only in manuscript illuminations from Cluny, from the end of the eleventh and the beginning of the twelfth century.

In the cap of the apse, Christ is enthroned as omnipotent ruler of the world. To the right and below the aureole, the arm of this imposing figure extends beyond the luminous sphere to pass the scroll of the law to St. Peter, who is accompanied by the other Apostles and four further saints. Beyond its inherent religious meaning, the motif has been interpreted as a symbolic expression of the act of consecrating the church in the sense of a "traditio legis", or handing over of the law, i.e. a specific homage on the part of papist Cluny to the Roman apostolic rulers.

The dating of the frescoes is not secure. The most frequently advanced dating to the first third of the twelfth century is supported by the paintings' influence on the famous sculptures by Master Giselbert in Autun (ill. p. 61). At any rate, these paintings represent a key paradigm for the art of Cluny, most of which has been entirely destroyed. Their features are just as unique in France as the row of in part Eastern saints represented in the half-figures in the socle zone. Regardless of the overall disposition, which is iconographically incompatible with these, the artist working in this Burgundian branch of Cluny surely relied on Byzantine patterns. He likely also authored the frescoes on the side choir walls, although the figures there, as in the martyrdom of St. Lawrence, appear both more awkward and more expressive and dynamic. The treatment of the drapery reveals convincing parallels as well: compact draperies that twine like elongated linear patterns along the parts of the body and open out at the joints to form flat islands.

The importation of Byzantine traits took place by various ways and on various levels. Basically it was a matter of an adaptation of the Byzantine drapery style derived from antiquity, which had been known for some time in the West, particularly in Italy. Cluny was a perfect melting pot, as the monastery possessed countless contacts with Benedictine monasteries in Italy, especially Montecassino. Then there were the many diplomatic missions to Rome, surely accompanied by artistic transfers – it is no coincidence that stylistic similarities are found between the paintings in Berzé and in the lower church of San Clemente in Rome (ill. p. 43); Farfa abbey in Latium was a Cluny foundation; there was a permanent and brisk exchange of manuscripts throughout half Europe; and conceivably artists of the most diverse background and training congregated in Cluny. If this does not justify us in speaking of a universal "Benedictine art", Cluny must nevertheless have been a more than regional center of incomparable meaning in the Europe of the day, where heterogeneous artistic currents converged and were merged into a superb synthesis.

> "st. нugo and his successor developed the organization of the order ... it consisted above all of the central rôle which the abbot of cluny played within the order."
> Jacques Hourlier, O.S.B.

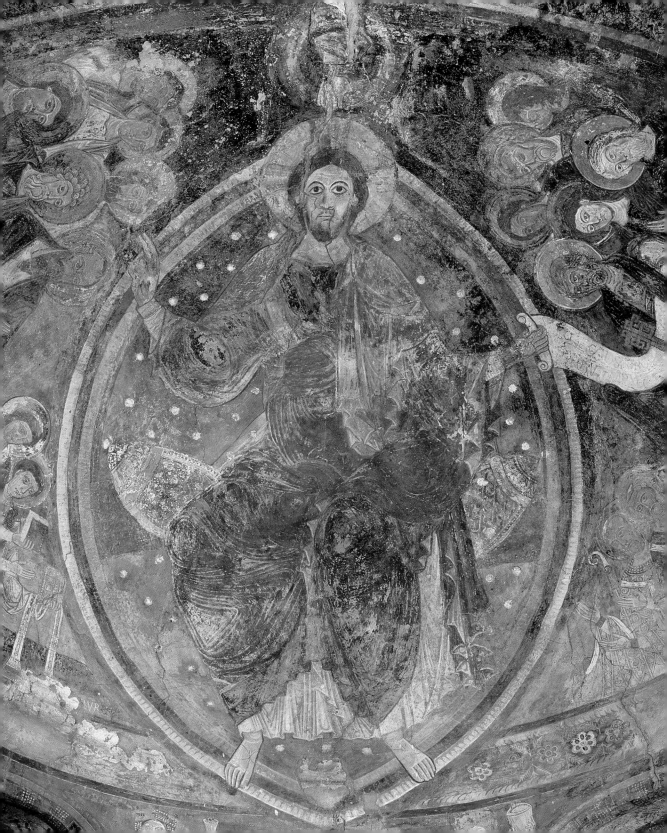

The christ from the vision of Ezekiel

Mural (mixed techniques), height 148 cm
Frauenchiemsee (Upper Bavaria), Frauenwörth

The founding of the convent on an island in Lake Chiemsee (Upper Bavaria) went back to Carolingian times, more precisely to the middle of the ninth century.

The Romanesque murals in the minster came to light in 1954 and their state of preservation was secured by the Department of Historical Monuments in 1961–1965. All that survives are rudimentary paintings on both side walls of the sanctuary on north and south. As they occupy an area above the later Gothic vaulting, the paintings have been made accessible to the public in the form of copies, located in the convent entryway. From the surviving fragments we may gather that the figures were once over two meters in height and that the separate picture fields measured about two-and-one-half by eight-and-one-half meters. The paint layers were applied in a very watery consistency which permitted rapid execution. In a last step, the artists added the haloes in whitish stucco relief. Finally they filled in the background in lapis lazuli blue.

Of the five figures on the north wall, the central one is definitely identifiable as Christ on the basis of the cross nimbus. The Redeemer occupies exactly the center of the image, in a hieratic frontal view. The two flanking figures at right and left indicate him by their gazes and gestures. The former represents an angel; of the latter, only half the face of a bearded man with halo survives. This group, we may assume, represents Christ in the closed portal ("porta clausa", conceived as a locked gatetower), as related in the vision of the prophet Ezekiel (44:1–4). The prophet (of whose inscription only the letters CH [K in the English spelling] remain) points with his right hand to Christ, as the angel on the other side explains the redemptional meaning of what he sees.

The incredibly fascinating head of Christ is a perfect example of the way in which two historical components overlap in the Frauenchiemsee works. On the one hand we have late antiquity, in the form of a pattern of light and shade applied with a broad, soft brush, modelling the face in three-dimensions and lending it great presence. On the other, the Byzantine component, a graphic pattern of stringent linear forms, more drawn with a pointed brush than painted, defining the wrinkles on the forehead, the eyelids, nose contours, and further details. In terms of art topography, the convent paintings are considered outstanding monuments of Salzburg mural painting, which, according to the sources, flourished in the eleventh century. The way in which the rich color combinations underscore the evocation of form is truly impressive. The latter rests especially on the stringency with which the plastic and ornamental, stylized values mutually supplement one another. Nothing superficial, let alone playful, has been permitted to dilute the effect. The gestures of the hands, too, have their own dramaturgy. Each and every line is charged with extreme tension and unprecedented pathos.

No viewer can escape the appeal of the generously modelled faces – the wide-open eyes with heavy lids, and the halfmoon-shaped shadows underneath which contribute to their sonorous accentuation. Everything contributes to that aura of sacred earnestness which makes these paintings an unforgettable experience.

"AS I looked, I saw a storm coming from the north, there was an immense cloud with flashing lightning surrounded by a bright light. The middle of the lightning looked like glowing metal."

Ezekiel, 1:4

The Prophet Daniel and King David

Stained glass windows with fired black lead contouring,
height exclusive of separating horizontal bands 221.5 and 224 cm, width 53.5 and 52.5 cm
Augsburg Cathedral, south high nave wall

The oldest stained glass cycle of large format still located at its original site (and only slightly supplemented) is found in the nave of Augsburg Cathedral. For a long time, these panes were dated to the late eleventh century or around 1100. In the meantime, experts have come to agree that they cannot have emerged until after the destruction wreaked on the city in the course of the Investiture Controversy.

The series, frontal, dignified representations of the prophets Daniel, Hosea, and Jonas, the prophetic King David, and – in a late-medieval copy – Moses. In each case the figures consist of two parts. All of these representatives of the Old Testament, clad in the costume of the Frankish nobility but with Jewish pointed hats, hold unfurling banderoles with quotations from their scriptures and sayings. The program was apparently originally supplemented by murals, remnants of which – several large haloed figures under canopies – have been uncovered.

Standing tall, rendered very straightforwardly yet monumental in effect, these figures possess a dignity that is underscored by their penetrating gaze, redolent of their visionary mission, directed straight at the viewer. The figures are of remarkable plasticity, to which the contouring contributes not a little. Their movements are reserved, reduced to essentials – upper arms pressed close to the body, lower arms bent and raised with decorum to chest or abdomen. The central axis of the figures, composed symmetrically around this vertical, corresponds to that of the windows, which lends figures and faces a geometric solidity.

Stylistically, the prophet windows in Augsburg Cathedral point to a Swabian artist of the highest rank. They are masterpieces not only of Romanesque but of all German art of the Middle Ages.

That such monumentality now entered the field of stained glass doubtless had to do with the growing dimensions of church windows at that period. While only a few small-format glass paintings are known from the Carolingian and Ottonian period, the Augsburg prophets, along with the windows from Neuweiler in Alsace, dating to 1145–1150 (now Paris, Musée de Cluny), reflect this increasing demand at a quite early point in time. Moreover, written records exist of extensive stained-glass cycles in the cathedrals of Speyer, Mainz, and Worms, all of which, however, have sadly been destroyed.

Soon after the Augsburg cycle was finished, the monk Theophilus – very likely identical with Roger of Helmarshausen, author of the artists handbook "Schedula diversarum artium" – first described the technique of glass painting. Separate pieces were cut from the colored panes, then assembled and fixed with the aid of strips of lead.

Not only in France but in the German-speaking regions did the Romanesque art of stained glass meet the highest demands, with an extraordinary formal and substantial diversity. This is shown, among other examples, by the *Charlemagne Window* (ill. left) from the Strasbourg Minster, dated either to 1180 or around 1200 (Strasbourg, L'Œuvre Notre-Dame). Charlemagne appears in a frontal pose on a golden, gem-studded throne in the overwhelming fullness of his power, holding scepter and orb, majestically sublimated and lent the status of sainthood by a halo. Every piece of glass cut to fit the various bands is of brilliant color and overlain with rich ornamental decor, which, as a whole, recalls the glory of glass mosaics in Byzantine churches.

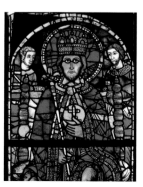

Charlemagne Window
from Strasbourg Minster,
c. 1180 / 1200

THE LAST JUDGEMENT

Stone, width 640 cm; height of figure of Christ 305 cm; height of doorjamb 76 cm
Autun, Saint-Lazare Cathedral, tympanum of the west portal

The cathedral of Saint-Lazare in Autun was one of the most important pilgrimage destinations of the high medieval period. And, alongside Sainte-Madeleine in Vézelay, it harbors the most extensive complex of Romanesque architectural sculpture in Burgundy: the tympanum, or field in the arch, of the west portal, fragments of a north portal, figured capitals in the interior. The chief master signed his name at the feet of Christ in the west portal tympanum: GISLEBERTUS. His style and that of his workshop is characterized by a great elongation of the figures, extreme relief, and an extremely subtle graphic play of line, as well as by very fine chiselwork that visually divests the stone of all ponderousness. The judging Christ as colossal, central figure owes much to a model from Cluny, which likewise already exploded the division into zones traditionally employed in such compositions.

The semicircular tympana of Romanesque churches might be likened to great posters that conveyed the story of redemption, but whose margins also included secular motifs. These arched fields, huge especially in France, were the result of impressive technical planning and immense investments of money in artists and materials. The unusual proportions of the figures in the Autun tympanum, especially in the Apostles group, mark an extreme within Burgundian architectural sculpture in the Romanesque period. The relationship between figure and ground is taken to its utmost limits, in that the sculptors have freed the figures in part from the ground while at the same time strictly correlating them with the planes of the foremost and hindmost relief layer. Every physical movement and every gesture takes place solely in parallel with and within these levels of reference.

Tympana representing the Last Judgement depict the struggle between good and evil, existential decisions faced by the faithful, which lead to an ultimate reward or punishment in face of the Majestas Domini, the Lord appearing in all his glory. A further, deeply compelling example of the Majestas theme in late-Romanesque France is the enormous tympanum of the former abbey church of Saint-Pierre in Moissac (Tarn-et-Garonne), with the Apocalyptic Christ enthroned in the midst of the four Evangelist symbols and the twenty-four eldest (in accordance with the Revelation of St. John, 4:2–8).

Naturally the Judgement in Autun – an apex of Romanesque sculpture – is likewise dominated by the judging Christ in his aureole, which here assumes enormous dimensions. To his right appear apostles, angels, the Heavenly Jerusalem, and Mary. To his left we see a dramatically rendered weighing of souls, where an angel carefully holds a scales with the chosen ones, a few of whom are already ascending to bliss in the eyes of God. A skeletal demon from hell desperately tries to pull the other tray of the scales down to his side. On the door lintel, finally, we see the resurrection of the dead, who are being divided by an angel into the blessed and the damned. The margin on the side of the eternally condemned is occupied by the edifice of hell, into which the sinners are being cast. Especially grotesque is the motif of clawed hands gripping the head and neck of one of the unfortunate.

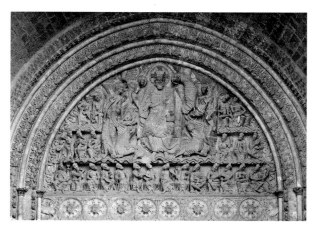

The World Judge, tympanum of the former monastery chapel
Saint-Pierre in Moissac, between 1120 and 1135

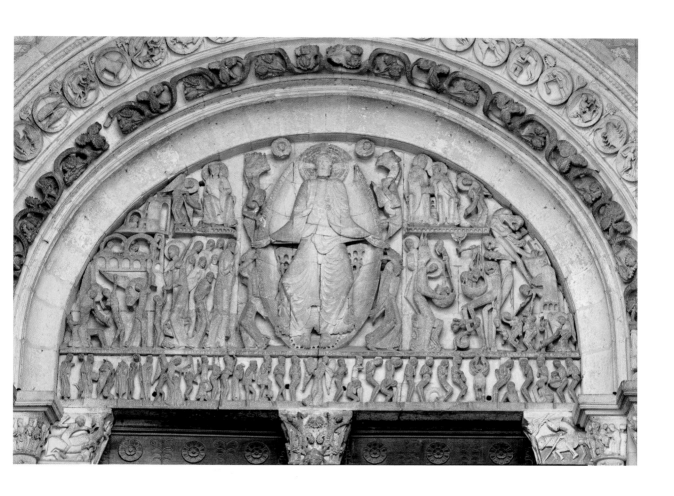

тhe "Golden Altar" of Lisbjerg

Rolled and chased sheet copper, gilded, ornaments in brown varnish;
the Virgin and Child in gilded bronze casting, width 158 cm
Copenhagen, National Museum

A small number of Scandinavian monuments now contain impressive configurations and superimpositions of antependium (altar screen), retable (altar superstructure), and large crucifix, resting on this panel but usually surrounded by an arched structure. Whether such imposing treasures of eccesiastical art once existed in other parts of Europe must remain open. It is certainly possible, but these, like so many other pieces of exquisite church furnishings, vanished from sight over the course of the centuries. The altar screens and retables of hammered and gilded copper over a wooden core found in Denmark, which evidently emerged as early as the middle of the twelfth century from local workshops and traditions, have entered the literature under the local term gyldne altre, or golden altars.

That from Lisbjerg, dating to 1135/40, was probably intended for the main altar of St. Mary's in Aarhus, which functioned from 1060 as the first cathedral church of the diocese. Later it will have come to the new cathedral, begun in about 1200, whence Bishop Jens Iversen passed it on in 1479 to Lisbjerg village church, because the churchman desired a more up-to-date altarpiece.

While the antependium shows scenes from the life of the Virgin, personifications of "pax" (peace) and "fides" (faith), and a train of apostles, prophets and saints grouped around the central madonna, the program of the retable front (40.5 cm high and 160 cm wide) is Christologically oriented, with the enthroned Redeemer under a central cloverleaf arch, flanked by "sol" (sun) and "luna" (moon) medallions, which replace the capitals of the pilasters supporting the arch. Under the round-arched arcades to left and right stands a row of Apostles. Above the center hovers a crucifix, created around 1100 for an unknown context and brought here fifty years later, encompassed by an arch that begins at the ends of the retable. Its vertex is crowned by an arcature rising towards the center and bearing relief images of the Redeemer, Virgin, saints and angels. Inscriptions appeal to Christ as ruler and judge of the universe, the Apostles as members of his court, and the cross as "remedium mundi", or remedy for the world.

The retable band in this and comparable specimens is relatively narrow and subordinated, in terms of overall impression, to the front of the antependium in particular. Its visual and iconographic task appears to have been to serve largely as a socle or base for the crucifix and the great arch, symbolizing the cosmic dimension of Christ's sacrifice to save men's sins in a way that is effective from a considerable distance.

Moreover, the gold altar of Lisbjerg, the oldest surviving example of its kind, represents the earliest and most perfect formulation of the cult of the Virgin in the northern European countries – the Madonna being shifted to the center of the antependium and thus, as it were, occupying the gateway to the Heavenly Jerusalem, flanked by heavenly hosts. Byzantine influences, combined with a touch of Anglo-Saxon art, may well have been the source of the figure style of this impressive piece of the goldsmith's art. In addition, the lower skirtboard is entirely decorated with intertwining animals in the manner of old Nordic or insular models (Irish-English, perhaps conveyed by way of manuscript illumination).

> **"Art stands higher than gold and precious gems, but at the highest point stands the donor."**
>
> Henry of Blois, Bishop of Winchester, before 1171

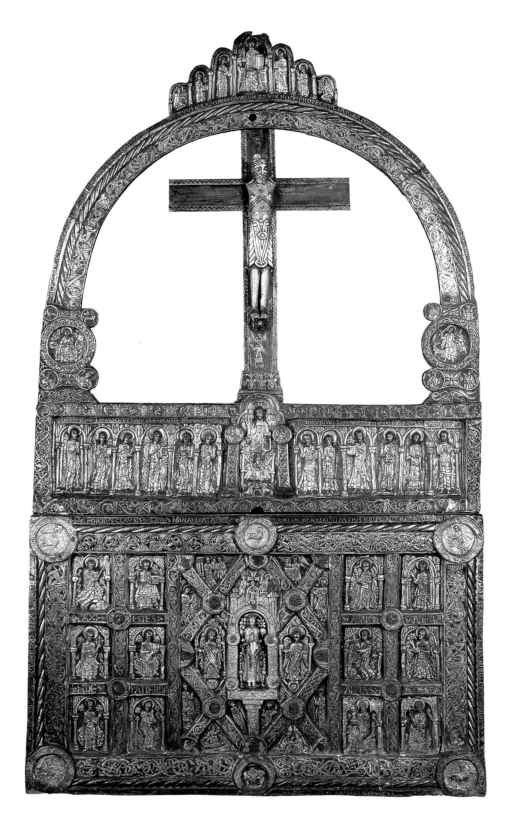

crucifix

Tempera on wood, 300 x 210 cm
Sarzana (Liguria), Cathedral

In addition to antependia and altar retables, wooden crucifixes, painted and cut out in the shape of the cross ("croce dipinta"), were among the earliest and most characteristic genres of Italian panel painting.

The example that goes back farthest in time is a work of the Tuscan school: the crucifix in Sarzana Cathedral, identified and dated by an inscription as a creation of Master Guillielmus (William). Located below the narrow cross title, the inscription is written in Latin hexameters, suggesting that Guillielmus was a clergyman and himself authored these learned verses.

The iconographically enriched scheme of all early crucifixes of the type is already present, full-blown in the Sarzana piece: a combination of a monumental (usually over-lifesize) figure of Christ with smaller auxiliary scenes and attendant figures. In the present case, these conform to the traditional crucifixion formula, comprising Mary and Jesus' favorite disciple, John, under his arms, then the two other Maries behind him. The smaller images to the left, reading from top to bottom, represent the Kiss of Judas, the Scourging of Christ, and the Maries at his grave; and to the right, the Pilate scene, the Deposition from the Cross, and the Entombment. Also visible, in the rectangular fields on the crossbeam above Christ's hands, are the symbols of the Evangelists, and below these, infant angels holding banderoles bearing the prophecies of Isaiah and Jeremiah. The rectangular field at the upper end of the upright bears an image of the Ascension, such that the Son, already ascended to heavenly heights, occupies the central vertical axis together with his Mother Mary in the midst of the Apostles.

The Sarzana crucifix avoids the drastic effects of a depiction of Christ's torment on the cross. Instead, the figure appears in all his slender dignity, with open eyes, raised on the cross not like a martyred body of flesh and blood but like the sign of a spiritual message of redemption. Stylistically, the work avoids a straightforward imitation of Byzantine patterns. As its mature formal language and highly developed technique indicate, it cannot be considered one of the first works of its kind, on the contrary suggesting the existence of an already flourishing production.

There was no immediate predecessor for such "painted crosses" in the field of Byzantine icons. Yet they must have experienced a boom in Western Europe as early as the Romanesque period. These crucifixes hung over or behind altars, but most frequently they stood on a rood screen, the partition between the chancel and nave of a church, or on a beam that stood in for the rood screen.

By the second half of the thirteenth century, such panel crosses were already very widely disseminated, especially in Italy. But they were found elsewhere as well. From the fascia arch in the northern German Cistercian church in Loccum, for instance, hung an over five-meter-high triumphal cross painted on each side with a superb crucifix (now in the intersection in front of the chancel; one side restored c. 1850). It dates to the middle of the thirteenth century. Rather than exquisitely finished carved works or metal crucifixes, the Cistercians apparently favored the less costly painted crosses, reflecting the abstention from all luxury propagated in the statues of their order.

"we forbid the presence in our churches or in any rooms whatsoever of the monastery of pictures and sculptures, because one's attention is especially diverted by such things, and thereby the benefit of a good meditation is often prejudiced and instruction in religious earnestness is neglected. Yet still we do have painted crosses of wood …"

Building regulations of the Cistercian Order, 1134, chap. 20

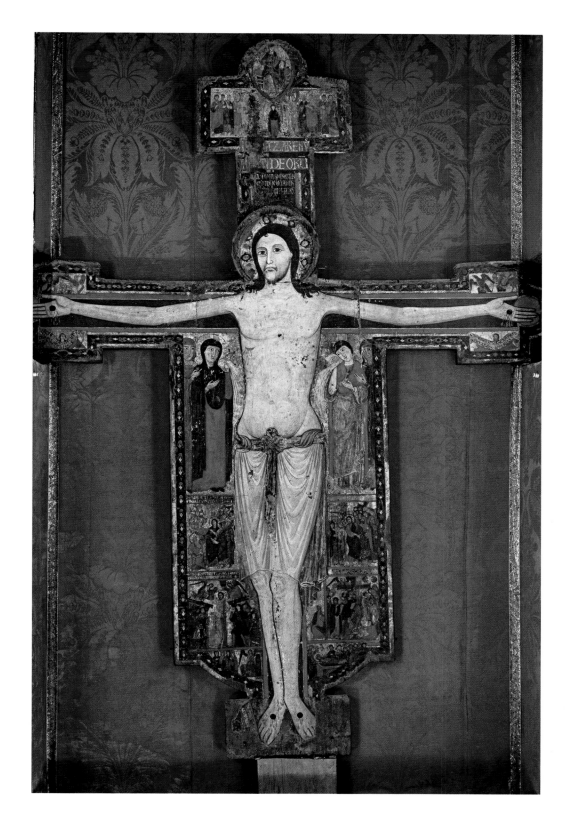

тhe Ascension of christ

Glass window (with a few abstract twentieth-century additions),
black lead painting in opaque strokes, height 168 cm, width 116 cm
Le Mans, Cathedral, south transept, second window

To our present knowledge, the earliest French stained-glass works are those in Le Mans Cathedral. Outstanding among the several groups of windows of various approach is certainly that depicting the Ascension, with its four bands occupied by the witnessing figures of Mary and the Apostles. The upper, lost register must have contained the main figure, Christ himself, in the midst of angels.

The red and blue checkerboard backgrounds have been partially renewed. Yet apart from an Apostle's head on the outer right in the topmost row, almost all of the panes are still original. The most striking features of all of the figures are their extreme elongation and geometric draperies. Stylistic correspondences are found in the nearly concurrent tympanum sculptures of Mauriac, and in the Noah scenes in the vault of Saint-Savin sur Gartempe (ill. p. 37), the choir windows in Notre-Dame-la-Grand in Poitiers, the stained-glass windows in Angers Cathedral, and finally in the early-twelfth-century miniatures in the sacramentary of Saint-Étienne at Limoges. The figures' heads appear closely related to those in the book illustrations of the "Vita Radegundis" of Fortunatus in the Poitiers Library, which have been dated to between 1100 and 1120.

The garments are intersected throughout by oblique lines in a different color. The figures' movements are self-confident, even lively; arms stretch out, heads are turned upwards, some bodies appear to undulate, legs are crossed to suggest steps being taken on colorful mounds of earth. The resulting vitality and tension, like the elongated proportions, geometricized contours, and interrupted vertical folds of the draperies, conform entirely with what one would expect of Romanesque art in western France. Technically, too, this window, like the rest in Le Mans, reflects a supreme quality of execution. The essentials of form are established by means of contours varying in application and touch; the less marked glazes contribute only occasionally to emphasize volumes. The energetic if limited palette employs red-blue contrasts above all, supplemented by green, yellow, purple and white. As Louis Grodecki points out, "The dramatic formal tension that heightens the opposition of the isolated figures, who are yet reunited by their shared excitement, the unreal character of the pictorial space, and the abstraction of the contours amplify the spiritualized, supernatural overall impression."

Although the dimensions of this Ascension window are relatively humble and the under-lifesize figures have a fragile appearance, the scene possesses an inward grandeur that recalls the enormous effect of Romanesque sculptures, for instance those on the former portal pillars of Souillac (ill. p. 53).

Based on the factors mentioned, it is certainly justified to count this window among the major works in all Romanesque art. Although it differs stylistically from the two other groups of stained-glass windows in Le Mans, it probably belongs to the same period, about the middle of the twelfth century.

The Le Mans windows were followed in France by the cycles in Poitiers, Saint-Denis, Chartres, Paris, Châlons-sur-Marne, Saint-Rémi in Reims, and other places, which, however, already marked the stylistic transition to early Gothic.

"тhe windows of our church were previously hung with cloths, but in your happy times the golden-haired sun shone for the first time through varicolored windows of paintings onto the floor, and all who see this are filled with great joy, and marvel at the multifariousness of the unusual work."
Abbot Gozbert, 982–1001

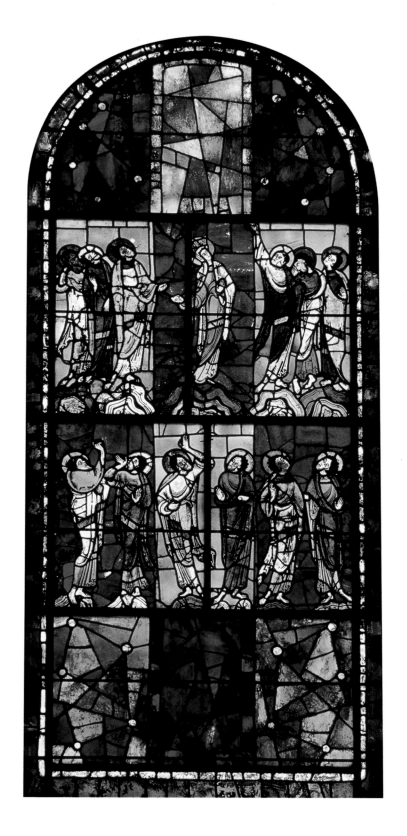

Luxuria

Mural (fresco)
Tavant (Indre-et-Loire), Saint-Nicolas, crypt

The decorations in the nave and crypt of Saint-Nicolas in Tavant, discovered in 1945, doubtless count among the finest achievements of Romanesque mural painting in France. Those in the apse, especially, exhibit a brilliant touch in the handling of lineature, an ornamental vitality of the flow of line. Their precise content is not easily defined. It includes subjects from Old and New Testaments (Adam and Eve, Cain and Abel, David as Musician and in the Lions' Den, Christ Enthroned, Christ in Limbo, the Deposition), scenes from the history of the Apostles (crucifixion of St. Peter), the psychomachia (struggle of the virtues against the vices), as well as cosmological motifs (Atlas figures and, possibly, signs of the zodiac). The dating oscillates between the second half of the eleventh, the middle of the twelfth, and the end of the twelfth century. One of the most knowledgeable scholars in the field, Otto Demus, convincingly suggests the second quarter of the twelfth century.

Auxerre Cathedral, crypt –
Christ on a White Horse,
c. 1150

The same workshop that adorned the choir in the upper church with a monumental decoration was evidently also active in the crypt, even though the technique and touch of the small-figured, unframed frescoes on a white ground, which apparently were never painted over, appear even more painterly, open, and sketchy than there. The most surprising feature of the individual compositions and figures is the expressive handling of every detail, which is especially evident in figures such as the *Luxuria,* personification of the vice of extravagance. French scholarship has attempted to explain this "élan sauvage" by German influences, an hypothesis which, according to Demus, is mistaken.

In Demus's opinion, much about this painting can be explained by its quite popular approach. The author mentions the popular votive motifs of crown of thorns and branching cross in the Deposition, the frequently strange cloud motifs, the flames in the descent into Hell – all of these being details that caution against an all-too-early dating. Demus sees the drapery motifs, the armor (in the psychomachia), and the facial types as clearly belonging to the late first half of the twelfth century, and detects cross-references between the murals in the choir of St. Nicolas and the c. 1150 depictions of holy horsemen in the crypt vaults of Auxerre Cathedral.

There, in the cap of the south trave, or section, at the intersection of a cross whose four fields bear angel medallions, appears Christ (identified by a cross nimbus) on horseback with a scepter in his outstretched right hand and his left hand raised in benediction. This brings the Redeemer into proximity with the type of the saintly knight or mounted emperor, a motif very popular at the time, especially in France (compare the Romanesque image in the baptistry of Poitiers). The symbolism of the Lord's advent may be further underscored by passages from the Apocalypse in which the vision of Christ the King leaving for the final battle is described, with a reference to the white horse: "And I saw the heavens open and behold: a white horse, and the rider upon it is called Faith and Verity and he judges and fights with Justice …" (Revelations, Apocalypse 19:11). Whether or not such a pointed iconography echoed the just reconciled Investiture Controversy – a conflict between secular and sacred power – cannot be determined with any degree of certainty.

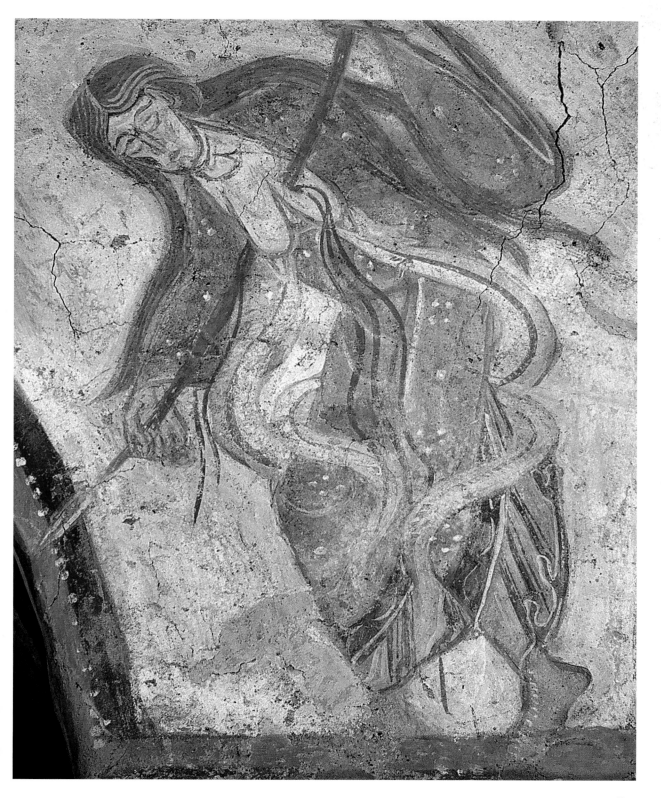

Bronze Door in Novgorod

Cast bronze sections – relief fields and framing – affixed with nails to solid wood planks,
height of both door wings 360 cm, overall width 240 cm
Novgorod, St. Sophie's Cathedral

The west portal of St. Sophie's Cathedral in Novgorod is fitted with two monumental bronze doors, which, however, were not originally intended for this site. They were cast in a workshop in East Germany, or more precisely, in Magdeburg. The question as to contractor and origin is answered to the extent that the doors include depictions of two bishops who are identified in the inscriptions: Alexander von Płock (1129–1156) and Wichmann von Magdeburg (1152–1192). As the latter became archbishop in 1154, the doors must have been finished shortly before. As the Magdeburg metropolite was prelate of the diocese of Płock (a town about one hundred kilometers northwest of Warsaw) and since it is known that an important foundry existed at the time in Magdeburg, these historical premises, bolstered by stylistic indicators, suggest that the Novgorod doors could have been fabricated in Magdeburg only.

It is not known when, how and why the doors came to Russia. Hypothetically the transport could be dated to the fourteenth century, when the explanatory Russian inscriptions may have been added. Each broad upper field on each wing is accompanied by six double fields with reliefs. Doors and fields are framed by heavy, nearly semicircular ornamented profiles. The inner double field on each wing bears a lion's head with ring, located halfway between top and bottom of the door.

The style of this artistically exorbitant work is High Romanesque. The masters who created it filled the rigorous grid of frames and fields with individual figures and figure groups, all of which evince a quite styl-

Bronze door, San Zeno, Verona, c. 1138

ized homogeneity. The overall effect, however, is anything but one of boring uniformity. Rather, it is characterized by a blocky concision and noble dignity that raises the depiction to the category of collective symbolic reference. Symbolism of this sort requires no illusion of space, no display of individual emotion on the part of the actors, no dramatically related plot.

The background of the fields is for the most part smooth, only occasionally being articulated by suggestions of line. The figures, depicted almost fully in the round, appear applied to the ground. Frequently shown in a frontal stance, each is formally self-contained and clearly contoured, and stands on a small surface, each to himself, without compositional relationship to the other figures in the tableau. Man, one might conclude, is part of a great world order that far surpasses human scale, whose message of redemption is conveyed in unusual detail and iconographic precision in the pictorial program.

Bronze doors must have adorned many important churches in that epoch of the Middle Ages (for the Ottonian door in Hildesheim, see ill. p. 10). From the early Romanesque period, more precisely the middle of the eleventh century, a door of this type has survived in the south side aisle of Augsburg Cathedral; the bronze door of the south portal of Gnesen Cathedral in Poland dates to the fourth quarter of the twelfth century. Italy still boasts suprisingly many works of the kind, found especially in the southern part of the country, in Pisa, and – a particularly famous example – in Verona.

There, the west portal of San Zeno has a two-wing door with forty-eight square fields arranged in eight horizontal rows. The wings, presumably completed in about 1138, surpass every other Romanesque bronze door in terms of the abundance and variety of their sculptural decoration.

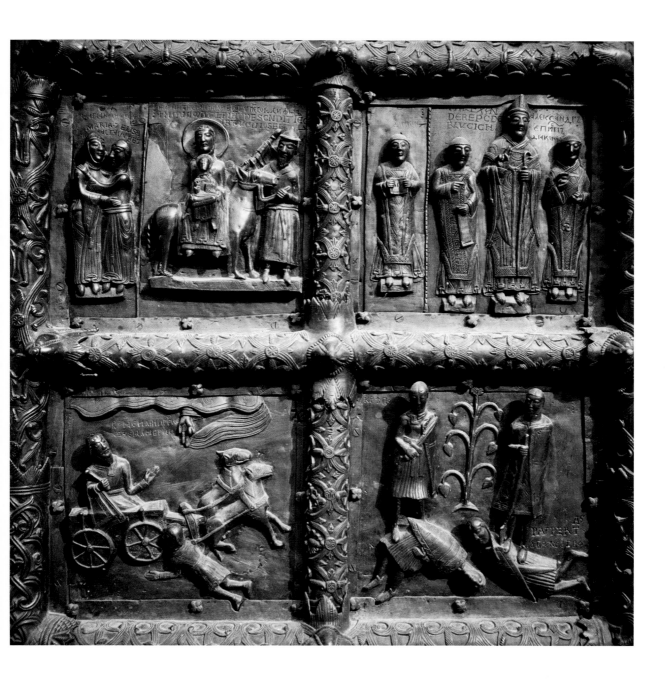

The scribe Eadwine

Eadwine Psalter, folio 283v: Tempera on parchment, 45.7 x 33 cm
Cambridge, Trinity College Library, Ms. R. 17.1

Sadly, no more than sparse remnants of Romanesque mural painting have survived in England. Examples are found in Hardham and Clayton in Sussex, in Copford (Essex), Kempley (Gloucestershire), and in Canterbury Cathedral. In Hardham one finds stylistic traits that reveal a knowledge of much older miniatures, from the Carolingian school active in Reims.

Apart from other sources of inspiration, as good as all mural fragments on the island reflect the influx of the Byzantine style, which doubtless went hand in hand with the close political contacts that existed at the time between England and the eastern Mediterranean region.

How such a network of relationships might have looked, can be gathered from a comparison between a mural of the third quarter of the twelfth century in Saint Anselm's Chapel in Canterbury Cathedral, and a miniature from the Eadwine Psalter. Of the decoration of this chapel in the south choir gallery, consecrated to St. Peter and St. Paul, remain only bands of ornament and a single scene, illustrating Chapter 28 of the Apostle's story: After landing on Malta and lighting a fire, Paul is attacked by a snake, which he immediately throws into the flames. The closest stylistic parallels to this outstanding composition are found in the Bible of Bury St. Edmunds (Cambridge, Corpus Christi College, Ms. 2), for whose pictures the illuminator Hugo received payment between 1121 and 1148. In conformance with these Bible illustrations, the mural is oriented to the new Byzantine wave of the time that apparently began in Sicily. At the same time, it evinces ornamental interior drawings similar to those in the *Eadwine Psalter*. This southern English psalter represents a special form of liturgical book, in that it establishes a concordance among three different translations of the psalms made by Jerome.

The psalm texts are accompanied by drawings that appear copied from the Carolingian Utrecht Psalter, yet are transformed into Romanesque style. The renown of the Cambridge codex, however, derives principally from the superb full-page "portrait" of the scribe Eadwine (possibly added to the somewhat older book c. 1150/60), a depiction of intrinsic grandeur well-nigh unmatched by anything of its kind in the twelfth century. The artist presents himself as a self-confident representative of a profession which medieval sources frequently place above that of the painter. That his work amounts to a service to God becomes evident from the composition, which adapts Eadwine's pose and ambience to the dignified images of the Evangelists in sacred art. Yet that his activity also results from artistic genius is shown by the verses in the interior frame, cited here: "S[c]riptorum princeps ego nec obitura deinceps laus mea nec fama …" (amongst the scribes I am the prince, neither my praise nor my splendor will ever founder …).

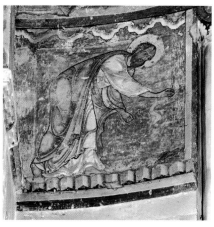

Paul throws the snake which attacks him into the fire, third quarter of the twelfth century

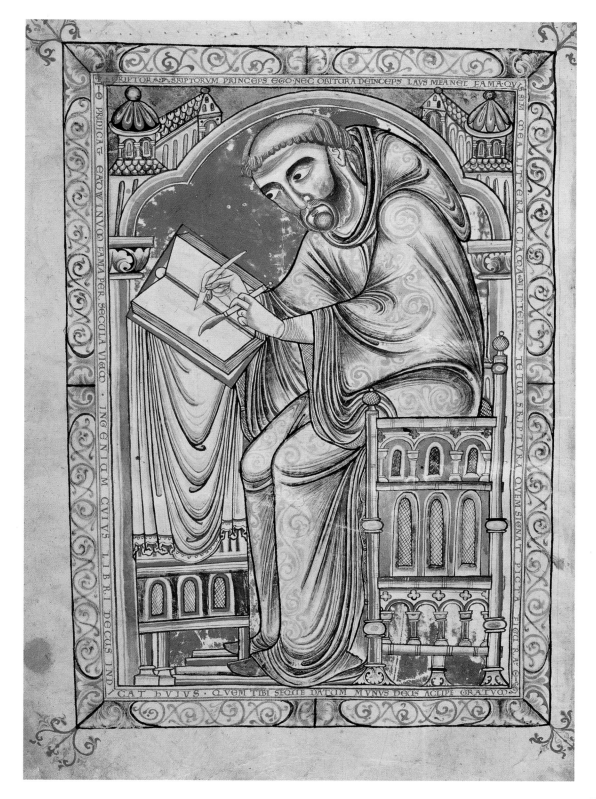

Portrait of Emperor Frederick I (Cappenberg Head)

Gilded and partially silver-plated bronze, height 31.4 cm (a fourth supporting figure on the lower battlements lost; head missing silver headband; eyeballs added in the nineteenth century)

Selm (Westphalia), Schloss Cappenberg, Chapter Church

Relatively small by comparison with the bust, the base of this fine piece of goldsmith's work, possibly from Aachen or the Maas region, rests on four dragon's or lion's heads, above them an octagonal castle wall with four corner turrets. Three angels, kneeling like Atlas figures, support the upper plate with battlements. On it rests the portrait head, which is affixed by means of cast pins to the middle tower of the base. Inscriptions on the two edgings at the bust's neck give the name of a certain Otto, who possibly had himself depicted in place of the fourth, missing angel.

These inscriptions refer to a second phase in the history of the singular work: Otto von Cappenberg, the godfather of Frederick I Barbarossa, raised this portrait head, presented to him by the emperor, to the status of a reliquary by adding hairs of St. John the Evangelist, and thereby consecrating the erstwhile secular sculpture to ecclesiastical service.

The fact that this head had originally represented Frederick Barbarossa is confirmed by a donation document of Otto's for Cappenberg Chapter Church, founded by him and his brother, of which he was provost from 1156 to 1171. His testament expressly states that the head was "formed after the emperor's face." This makes the bust the first independent and at least partial portrait likeness in Western art since the Carolingian era. The ruler's headband, likewise represented for the first time in medieval art, indicates the influence of late-antique heads of caesars.

This conscious quotation of late antiquity illustrates the continuum of tradition that extended from the Roman imperial past to the medieval emperorship. The base, in contrast, recalls contemporaneous depictions of Frederick I on seals. The ruler's bust in medieval vestments overtops the walls of Rome (one might also think of the Heavenly Jerusalem, but in all probability Rome, the "urbs aeterna", or Eternal City, was intended), demonstrating not least the emperor's claim to the former imperial capital – confronting the equal claim of the papacy. It was not for nothing that Frederick Barbarossa, even before his coro-

nation in 1155, emphasized that he had received divine right to rule not from the pope but from God.

Virtually everything about this wonderful piece is extraordinary, especially the attempt to transform the generalized, iconic representation of a ruler by adding characteristic traits of Barbarossa's features, individualizing them to the greatest extent conceivable or depictable in the Middle Ages (if by no means comparable to the modern understanding of a portrait, especially the hair and beard reflecting classical models and a typical Romanesque stylization).

Whether or not the *Cappenberg Head* was used liturgically after its conversion into a reliquary cannot be determined. Technically speaking, it could have been used to hold incense, although it was never put to his purpose in Cappenberg. As Anton Legner notes, "The visual magic of this object and the verism of the effigy [i.e. portrait] engender the fascination this work of art exudes."

"HIC Q(VO)D SERVETVR DE CRINE IOH(ANN)IS HABETUR TE P(RE)CE PVVLSANTES EXAVDI SANCTE IOH(ANN)ES."

"what is kept here is from the hair of John, o hear, st. John, those who entreat you in prayer!"

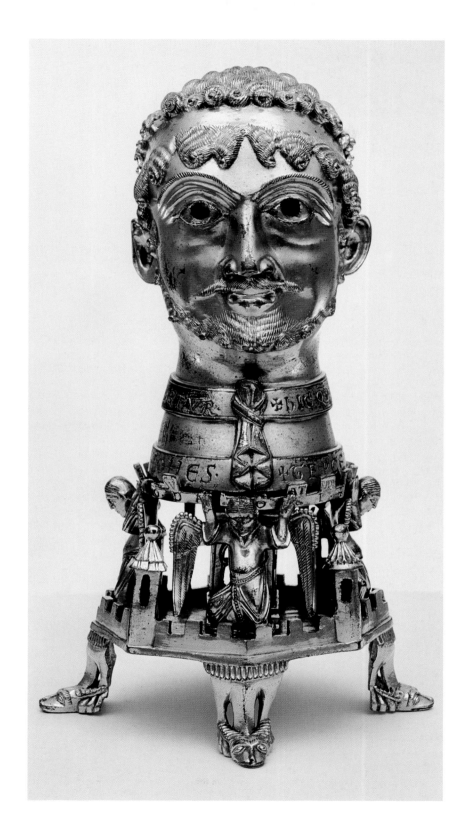

pórtico de la gloria

Portal
Santiago de Compostela, Cathedral

The building of the majestic pilgrimage church of Santiago in Compostela, northwestern Spain, began in the year 1078. Erected over the only mortal remains of the apostle, apart from those of Peter and Paul, known to Western Christianity, and raised to cathedral status in 1124, the church became a culmination of eleventh/twelfth-century Spanish Romanesque architecture.

The greater part of construction work fell in the tenure of the energetic Bishop Diego Gelmirez, who even used captured pirates as slaves. The choir hall was completed in 1122. The disposition of the monumental edifice may go back to French models (although there is still some controversy on this point). The roofing of the nave with a half barrel vault in turn influenced many Romanesque churches in France.

Located in front of the west entrance is the *Pórtico de la Gloria,* whose high-ranking sculpture program was created by a certain Master Mateo in 1168–1188. The portal proper is flanked by the two great west spires. It encloses a space divided transversally into four bays with heavy crossribbed vaults, which opens to the nave through three portals. The original exterior façade was destroyed and integrated in 1738 into a new, overall west façade. All three portals to the nave are occupied by the most imposing and artistically superb sculpture program from the Romanesque era – more precisely from the apex of its development there – which the Iberian peninsula contains.

James occupies his rightful place on the right face of the middle portal, after Saints Peter and Paul but before St. John. This group of four on richly decorated bases whose monsters symbolize the human vices stands opposite the four great Old Testament prophets. It is extremely unusual to see James here a second time, in a position that rightly should be occupied by Christ. He is enthroned on the central pillar of this portal in the pose of Divine Majesty, over the Root of Jesse and below a representation of the "Gloria in excelsis", the heavenly choir of jubilant angels.

True, Christ dominates the tympanum over James' head. Yet it is the Apostle James who visually receives the pilgrims. He holds a scrip-

ture roll in his right hand and rests his left on a T-shaped staff, which plays a role in the legendary conversion of the sorcerer Hermogenes. The same staff is revered by pilgrims in a bronze container in the basilica.

Master Mateo was one of the very great artists in his field. The achievement of depicting a wide-ranging figurative subject in this three-portal ensemble and raising it to a veritably classical ideal, was a pioneering one, and that not only for Santiago de Compostela but far beyond.

At a period when mass media were unknown, the ecclesiastical sculptures in the churches along the pilgrimage routes fulfilled a very similar purpose. They visualized the pilgrims' wishes, fears, and temptations, led them along the paths sanctioned by the church, and theologically accentuated the story of redemption in accordance with the specific traits of each place of worship and pilgrimage destination. Mass pilgrimages functioned as an omnipresent challenge to art to convey pious attitudes and religious visions of the world to people of all social strata. In this context, the pictorial program of Santiago de Compostela played a formative role, even though it came at a relatively late date in the development of Romanesque culture.

"This church shines in the resplendence of the wonder of st. James. And forsooth, health is once more restored to the sick, the blind man could see, the tongue of the mute was undone … he who walks through the portals and ascends in tribulation shall be felicitous after having immersed himself in the consummate beauty of the church."

Pilgrims' guide, c. 1139

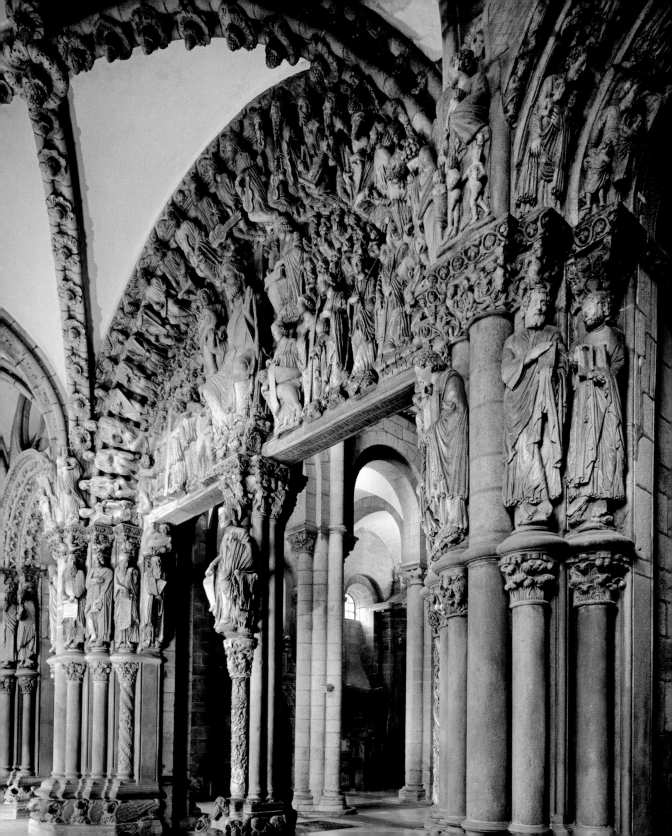

majestas Domini

Murals (frescoes with secco applications)
Schwarzrheindorf, St. Mary and Clemens', upper church

The contractor of the Romanesque church in Schwarzrheindorf, near Bonn, Arnold II of Wied, who held the office of Archbishop of Cologne from 1151, left no written record of his motives in erecting the double chapel. It would be interesting to know whether he was thinking primarily of a sepulcher, a palatine chapel, or a church which would reflect the power and influence of the archbishopric of Cologne or indeed the brilliance of his own career.

The extensive frescoes were often dated in the earlier literature to about 1151, in parallel to the church's year of consecration. More recent investigators, for better reasons, advocate the third quarter of the century or an even somewhat later phase. Unfortunately the frescoes have been in part considerably disfigured by later "restorations". In the upper church, flanking the apse, the program represents John the Baptist, St. Stephan, Peter and Lawrence, and below them ten further saints. In the fields of the ribbed vault in front of the apse appear apocalyptic scenes centered around the Lamb of God.

The paintings in the lower church, by other hands, depict in a comparatively graphic, concentrated style the destruction of the Old and erection of the New Jerusalem, based on the Ezekiel commentary by Rupert von Deutz (1075/80–1130). The concha of the cross arms (the church is built on a cross-shaped plan) contain Christological de-

pictions. If the surviving imagery can be trusted, the swooning of Mary found in a Crucifixion there would represent a surprisingly modern motif for the twelfth century. Especially enigmatic are the four seated figures of rulers in the transept niches. These might represent the four worldly kingdoms which, according to Rupert von Deutz, must yield to the kingdom of Christ (Nebuchadnezzar, Cyrus, Alexander the Great, Caesar), or perhaps the great "Roman" emperors Augustus, Constantine, Theodosius, and Charlemagne (unfortunately these figures in particular have suffered greatly under "interpretational" retouching).

The imposing *Majestas* in the upper church and the identical subject in the Cappella Palatina (an intriguing parallel in name) in Palermo, c. 1150, possess a few fundamental analogies in terms of pose and gestures, drapery and throne architecture. The affinities between frescoes in a Romanesque church on the Rhine and a so-far distant Norman palace chapel on Sicily might initially appear baffling. Yet there is a convincing explanation for this: The Cappella Palatina was built in the middle of the twelfth century, likely in the reign of Roger II. Its mosaics were executed at the same period. At about the same time, as mentioned, Arnold von Wied, chancellor of the Hohenstauffen emperor Conrad III, had the double church of Schwarzrheindorf built. The paintings there were executed in about 1170 or 1180 – a decade of the twelfth century in which close political contacts already existed between the Hohenstauffen dynasty and the Normans, who then resided in Palermo. Moreover, in 1186 Emperor Henry VI married Constance, a daughter of the Norman Roger II, and thus inherited the Norman empire. The Byzantine style that had entered countless monuments of art in southern Italy and Sicily rapidly spread to the spheres of Hohenstauffen power and influence in the Holy Roman Empire. Soon the Byzantine idiom advanced to become the visual lingua franca in the German-speaking lands. Schwarzrheindorf provides striking evidence of this development.

Majestas Domini – apse mosaic in Palermo,
Cappella Palatina, c. 1150

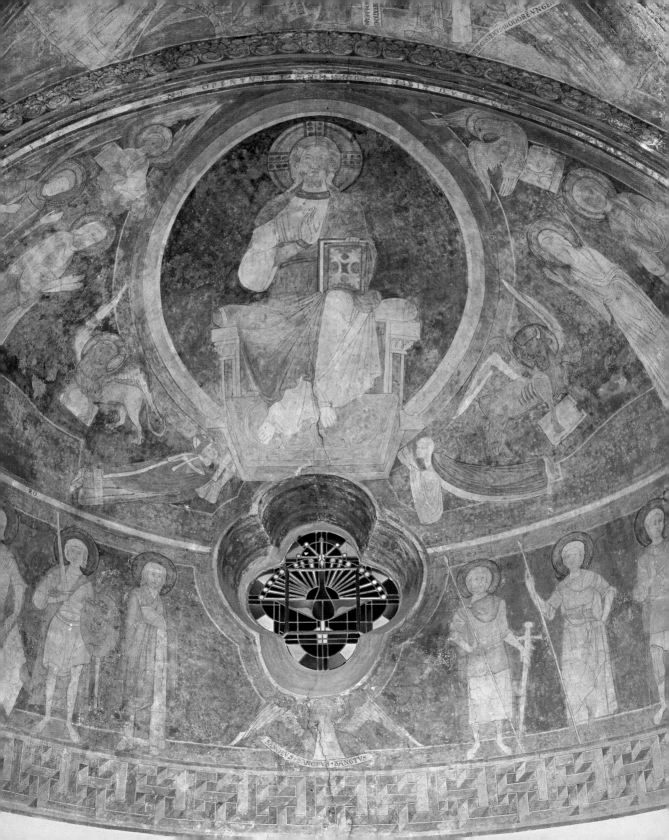

christ pantocrator

Mural (fresco with secco applications)
Léon, Panteón de los Reyes, Colegiata de San Isidoro

The Panteón de los Reyes of San Isidoro in León has been extolled as the "Sixtine Chapel of the Romanesque Era", and not entirely unjustifiably so. In this sepulcher of the kings of Castile and León, a hall located immediately in front of the Colegiata, a southern French or Catalan artist and his workshop painted intriguingly beautiful wall and ceiling frescoes around 1180. If the specimens in the main apse of San Clemente de Tahull (ill. p. 49) mark the culmination of Spanish fresco painting in the first half of the twelfth century, the almost entirely preserved frescoes in the Panteón de los Reyes represent the zenith of this art as the century drew to an end. Neither group of works was surpassed in its time; both belong among the outstanding achievements of Romanesque painting not only in Spain but throughout Europe.

The Panteón frescoes are generally dated to the reign of King Fernando II (1157–1188). We in fact find, at the feet of Christ Crucified on the east wall to the left of the former entrance, a depiction of a kneeling royal couple: on the left, as the inscription indicates, Fernando II, and on the right, the queen, next to her the remnant of an inscription, the letters "Ca" – surely part of the name "Urraca." Yet as both the king's first and third wives bore this name, we cannot be certain whether the inscription refers to Urraca of Portugal, whose marriage was divorced in 1175, or Urraca López, who wed Fernando II in 1181.

The cycle of wall and ceiling frescoes begins in the northeast vault with the apocalyptic vision of the "Ancient of Days". It continues to the south, after a band representing symbols of the months, with a Majestas Domini containing an iconographically quite rare representation of the Evangelists, their faces being replaced by those of the animals associated with them. Below this triumphal image on the east wall appears the Lamb of God. The next vault shows the charming and well-known scene of the Annunciation to the Shepherds, enriched by many a genre motif, and on the east wall below it, the Birth of Christ. On the south wall we see Annunciation and Visitation, and the Adoration of the Magi. The fourth vault contains the Massacre of the Innocents, the fifth the Last Supper, the sixth remnants of Passion scenes, followed by the Seizure of Christ. It need not necessarily have been, as was sometimes formerly maintained, an itinerant southern French artist under whose supervision these paintings – impressive despite their somewhat uneven quality due to the employment of assistants – were made. Yet French influences are nevertheless very much in evidence. These are accompanied by Italo-Byzantine elements and an underlying, typically Spanish tenor.

Out of this combination, images have crystallized which exhibit an immense inventiveness of design, the compelling magic of subdued yet luminous colors (mainly bluish-greens, reds, and deep browns), an abundance of surprises in content, and a profound visionary force.

With every glance one grows more and more astonished at the improvisational charm of the lineature, the decorative elegance of the composition, and the masterful interplay between parts and whole. The lavishly draped figures have the effect of a translation from contemporaneous Spanish sculpture into the fresco medium. Neither concrete predecessors nor clear successors of these unique frescoes can be detected.

The Annunciation to the Shepherds, c. 1180

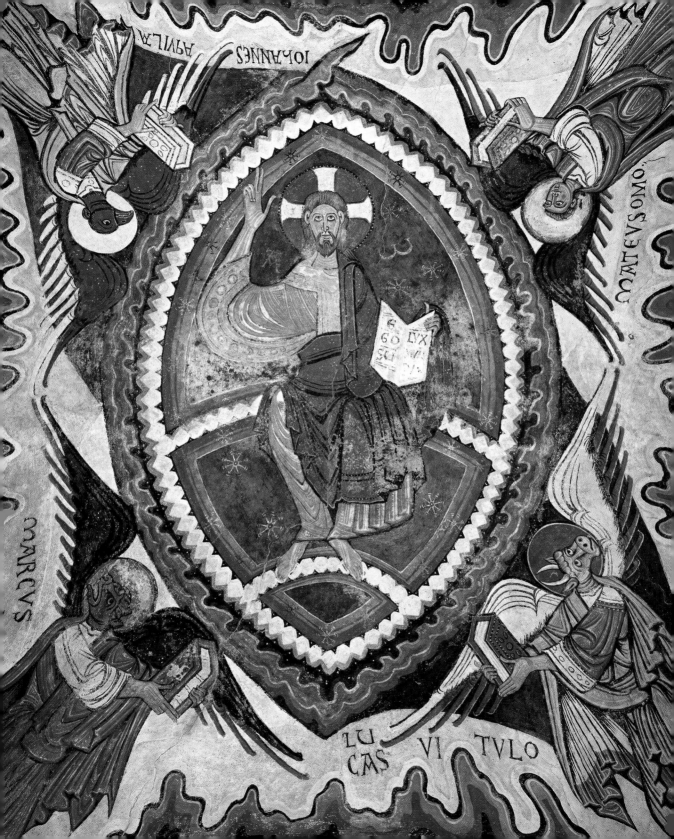

ascension cupola

Mosaics
Venice, San Marco

The interior of St. Mark's in Venice is like a symphony in color, gold, and the mysterious shimmer of light reflecting from the gold-ground mosaics. All sense of a bounded space disappears. Certain sections of the mosaics were originally supervised by Byzantine masters, before Western artists began increasingly to impose their local Romanesque style. After the earliest decorations in the narthex, or main entrance area, and the apse, both datable to the start of the twelfth century, in the 1170s Byzantine mosaicists began the decorations in the main nave cupolas and on the supporting arches between them – work that lasted about sixty years all in all. The apex of the east cupola bears a medallion with the image of "Christus Emmanuel", the youthful Christ, as prophesied by Isaiah (7:14), or at any rate in the interpretation of this prophecy by Matthew (1:23). Christ is surrounded by prophets and the "Maria orans", the praying Mary, whose pictorial formula was reserved for the apse in Byzantine churches – Romanesque churches in Sicily likewise have the slender figure of the stand-ing Madonna, set below the universal ruler, known as the Christ Pantocrator.

To return to San Marco, the central cupola is filled with the Ascension of Christ. The west cupola is devoted to Pentecost, with the "hetoimasie", or empty throne, awaiting Christ, surrounded by the Apostles infused with the Holy Spirit. This mosaic shows only eight of the Apostles, but accompanied by the four Evangelists, which may be due to the fact that Venice's doge and state church was not only consecrated to one of the four Evangelists, St. Mark, but possessed relics of the other three, Matthew, Lucas and John.

The pigments used in the mosaic tesserae are of the highest quality. Derived from lapis lazuli, copper, gold, silver and iron, they were mixed with or applied to the glass, and when the brilliance and intensity of the glazes were thought insufficient for certain details, the artists resorted to pure gold and silver or shining white. While the human faces of the Apostles are shot through with black shadings, the incarnadine of Christ, Mary, and the angels is heightened with white, as if their features emanated divine light.

San Marco is one of the most fascinating examples of the way in which Byzantine specialists instructed Italians in the mosaic art, providing the basis for the development of their own, independent formal ideas. The Cathedral of Monreale is another, no less striking example. There, mosaics from the period of the Norman ruler William II (1153–1189) cover nearly the entire interior: creations of a local Sicilian workshop under the supervision of Greek masters. By the time the mosaic work was completed in about 1190, migrating Greek artists appear to have brought the Sicilian mosaic style to lower Italy and even as far as Rome.

Apse mosaic in Monreale Cathedral, second half of the twelfth century

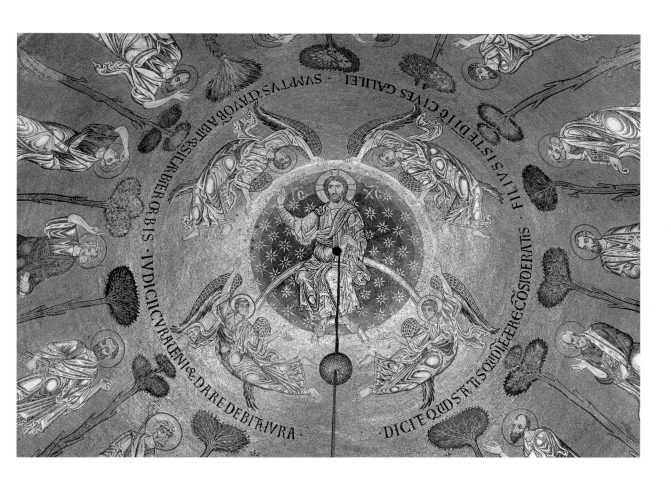

samson and the Lions

Small email panel from the "Klosterneuburg Altar", height of retable 108.5 cm, width of middle section 263 cm, width of side wings 120.5 cm each
Klosterneuburg, Augustinian Choir Chapter

Currently serving as an altar retable, or superstructure, this exquisite work can look back on a long and complicated history.

In the course of repairs in 1329 or 1331, Provost Stephan von Sierndorf supplemented the email work created in 1181 by the brilliant goldsmith Nicolas of Verdun (recorded between 1181 and 1205) and converted it into a winged retable which, opened to its full extent, was over five meters in width. At the same time, panel paintings were mounted on the reverse of the middle section and wings.

Originally the email plaques were located on an "ambo", a type of chancel, about whose form the experts have yet to reach full agreement. At some point, probably in the thirteenth century, they were removed and combined with the cross altar, perhaps as an antependium or screen, or perhaps already in the form of a retable, a "golden panel" of the kind familiar from the Pale d'oro in Torcello and San Marco in Venice. At any event, the winged retable is composed of the emails, forming their "setting", framing and presenting them. By opening and closing the retable the images, as in a reliquary, are as it were "made to appear". In terms of the system of theological exegesis known as typology, this array of emails, the largest known from the Middle Ages, juxtaposes scenes from the story of redemption at Christ's time with corresponding subjects from the Old Testament in which the New Testament appears prefigured. The Old Testament scenes are divided into those which occurred before and after Moses's establishment of the Law. The middle horizontal row of emails SVB GRATIA (at the period of "mercy") correspond to a superposed ANTE LEGEM (the period before Mosaic Law) and subposed SVB LEGE (the period under Mosaic Law). This typological series is followed by six panels with depictions of the Second Advent of Christ and the Last Judgement, distributed among all three vertical rows.

Nicolas of Verdun's understanding of the human body and its organic motions, and his ability to represent these in the classical sense, increased as work progressed, as becomes clearly evident in the sequence of plaques. The transition from a very schematic rendering of the figures to a relaxed, organic depiction, as well as to proper proportions of figure and drapery – as most obvious the Samson scene, as it were a legacy of classical depictions of Hercules – surely resulted from a knowledge of late-antique ivory diptyches, bronze and silver statuettes, and influences from Byzantine art (the last only with regard to iconography, not with regard to the formulaic nature of Byzantine design).

Nicolas came from the tradition of the Maas School, Liège having apparently been his artistic home. A second center of inspiration was the Rhenish School around Cologne. This outstanding artist may be considered the, or at least one of the earliest creators of the treatment of drapery known as the trough-fold style. Based on classical works, this style is characterized by drapery folds that move from extreme flatness to deep, shadowed troughs, thus modelling the figure beneath the garments. An identical approach is found later, in the classic Gothic sculptures in France, especially in Reims and Strasbourg. Accordingly, it is quite justified to call Master Nicolas one of the fathers of the Gothic style who began to put the premises of Romanesque behind them.

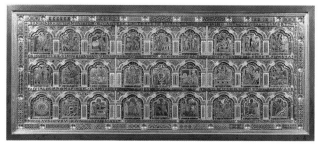

The "Klosterneuburg Altar", the emails completed 1181

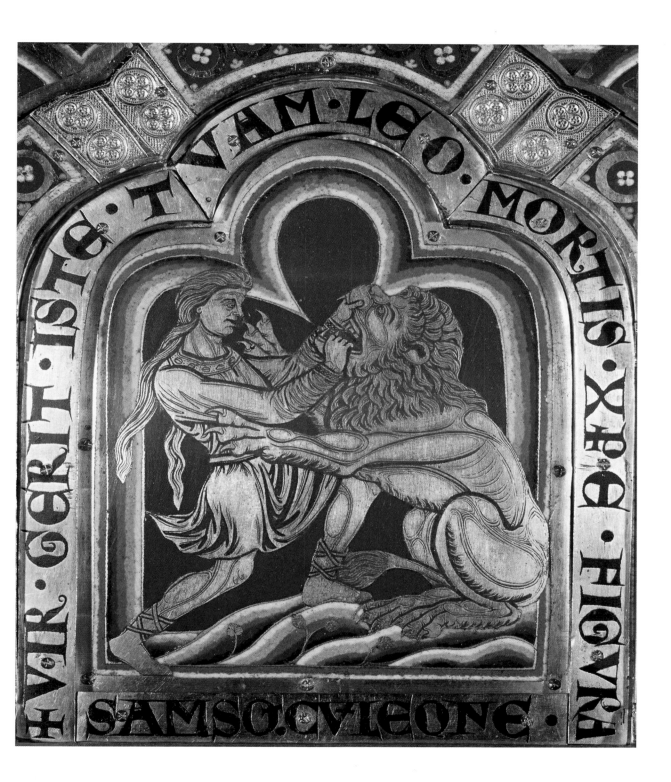

coronation of Henry and mathilda

Evangel of Henry the Lion, folio 171v: tempera on parchment, 34 x 25.5 cm
Wolfenbüttel, Herzog August Bibliothek, Codex Guelf. 105 Noviss. 2°

===

Hardly another twelfth-century nobleman gathered around him a more distinguished and in part innovative circle of artists than Duke Henry (actually Heinrich) the Lion.

In the latter half of the twelfth century, in the former castle precincts of the city of Brunswick, opposite St. Blasius' Chapter Church, there rose the monumental bronze statue of a lion, probably fabricated in a local foundry (the original now in Braunschweig, Herzog Anton Ulrich-Museum). A marvel of casting technique, the lion stands upright (ill. p. 22), its long torso poised, its front legs straight as a die and trembling with contained energy, its rear legs outstretched, with magnificently curling mane, tail in a great downward arc, maw gaping in a roar. This, the first large-scale freestanding sculpture of the Middle Ages, is redolent with aristocratic self-confidence and self-representation. It is a monument to the Guelph dynasty, whose heraldic animal was the lion.

Duke Henry (reigned 1142–1180) was one of the most intriguing figures of the German Middle Ages. King Henry II of England became his father-in-law, Richard the Lion-Hearted, his brother-in-law; Eleanor of Aquitaine, daughter of a noble troubadour, was his mother-in-law. In 1156, Saxony joined Bavaria to become his second dukedom. In 1158, Henry founded the city of Munich; in 1159 he expanded Lübeck into a powerful sea-trading harbor. Then, in 1176, a disaster occurred, a conflict with Emperor Frederick Barbarossa, who brought Henry's downfall and twice sent him into exile before finally reinstating him in part of his domains.

It was this same Henry the Lion who commissioned an exquisite evangel (bought for the Federal Republic of Germany at a 1983 Sotheby's London auction for the mind-boggling sum of 32 million marks). As the book presumably belonged to the liturgical appurtenances of the St. Mary Altar donated in 1188 to Brunswick Cathedral, it is probably justified to associate its emergence with this date. Its ornate execution is singular for the period and the prevailing artistic landscape. The format is unusually large, the illumination of surpassing richness, the colors – including much purple and gold – combine into a luxurious symphonic harmony. Several hands in the scriptorium of the Saxon Benedictine monastery of Helmarshausen were certainly involved in the execution.

The miniature illustrated opposite is the second image of the ducal couple in the manuscript, the first occurring in folio 19r. In the lower half we see the coronation of Henry and Mathilda by the hand of God. Behind the kneeling duke appears his father, Henry the Proud, and his mother, Gertrude, as well as their parents, Emperor Lothar III and his spouse Richenza. Mathilda is followed by her father, King Henry II of England, then his mother and an unidentified lady. The upper half of the picture is occupied by a half-figure of Christ, surrounded by angels and numerous saints associated with the ducal house. In the corner quadrants we recognize, above, Sponsus and Sponsa, the bride and bridegroom of the Song of Solomon, and below, St. Paul and St. Zachary.

In the dedicatory verse on folio 3v a certain Herimann gives his name and describes the noble book as the result of his diligent labor. Though scholars have occasionally identified Herimann as the responsible illuminator, the physical and mental effort involved in writing meant that it was almost always the scribe of such medieval books rather than the painter who was thought worthy of mention by name.

"It is more meritorious for him to lay his hand upon the quill than upon the plough, to draw the divine words in lines upon the leaves than furrows upon the fields. soweth upon the pages the seeds of divine words, and if the harvest be mature, that is that the books are complete, the hungry readers shall be sated and the heavenly bread shall allay the deadly hunger of the soul."

Petrus Venerabilis, Abbot of Cluny, 1122–1155

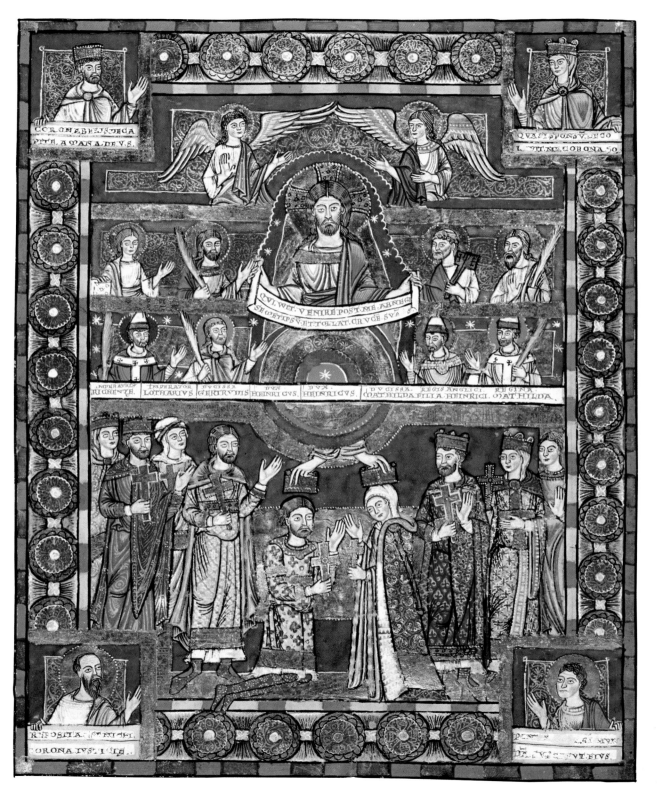

madonna

Pappelholz mit ursprünglicher Fassung, Höhe 184 cm
Berlin, Staatliche Museen zu Berlin – Preussischer Kulturbesitz, Skulpturengalerie

Seated on an exquisitely adorned pillared throne, the over-life-size Madonna is rendered in accordance with the nikopoia scheme – in stringent, dignified frontality, in her lap the Child giving the gesture of blessing. The Italian sculptor has changed the Byzantine veil ("maphorion") into a kind of cap, whose abstract spherical form is like a cupola over the slender face with eyes gazing into the distance. The garments are draped in fine layers and strict symmetry, and the Virgin's mantle is gathered in deep folds over her lower arms. The strict regularity of the female figure contrasts to the pose of the Christ Child, who raises his right arm as he holds the globe in his left. The oblique line described by his mantle, falling over his shoulder, is continued by a strong diagonal over the right knee.

The elaborate relief on the base of this wonderful Italian Madonna sculpture contains a four-line inscription saying that the carving was executed in the Year of Our Lord 1199 by Presbyter Martinus, i.e., by a priestly artist. It also tells us that the work was commissioned by a certain Abbot Petrus. As we gather from other sources, this abbot headed the Camaldolese Convent in Borgo San Sepolcro (Emilia-Romagna) around the year 1200.

Moreover, the inscription refers to the symbolism and meaning which this image of the Virgin, like so many similar ones, had for the faithful at the time. Mary is addressed as the throne or seat chosen by God become Man. Her function as seat of wisdom ("sedes sapientiae") is underscored by the two lions be-neath the footboard. These allude to the throne of Solomon, surrounded by lions, on which the Solomon of the New Testament, Christ – still a child but with the appearance of the universal ruler – has now taken his seat. In view of this carved figure we realize that our conception of Romanesque painting must be supplemented by the category of polychromy, the painting of wooden or stone sculptures.

Many of the sculptures of this era unfortunately bear only remnants of their original polychrome finish. Yet despite the fact that only a limited number of comparable pieces still exist, a few conclusions can be drawn from them. Whereas the outward appearance of the sculpture of the tenth and early eleventh century (Ottonian or pre-Romanesque) was almost exclusively determined by an application of precious gold or silver, this changed with the advent of the Romanesque. Now works were ever more frequently painted in color (which did not preclude an occasional partial use of gold or silver leaf). One of the several consequences of this new practice was to make the appearance of such votive figures a trace more naturalistic than that of earlier ones, if only slightly and not so forced as in many Gothic figures. Furthermore, their polychome finish tied the sculptures in with the frescoes on the church walls around them.

A fine example of this is the Freudenstadt Lectern. The garments of the Evangelists on its shaft are finished not in precious metals but in pigments alone, colors of an intensity that matches that of Romanesque mural and miniature painting. Here, too, the colors have been used to suggest shading and modelling even in places where no hollows have been carved out.

**Freudenstadt, Stadtkirche:
Lectern, third quarter of the twelfth
century**

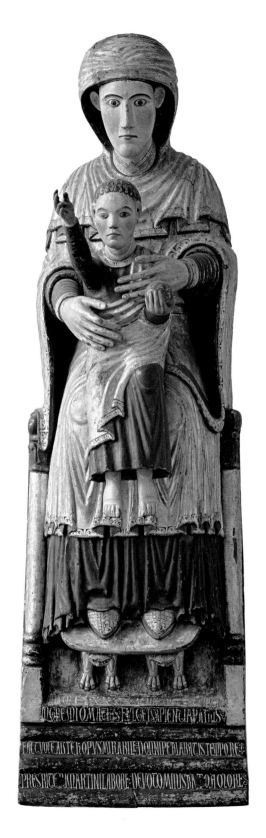

Annunciation to the virgin and the visitation

Mural (fresco)
Castel Appiano / Burg Hocheppan (Tyrol), Castle Chapel, detail of the south wall

The consecration date of 1131 for the Castle Chapel of the southern Tyrolean Dukes of Eppan bears no relevance to the fresco work, which must be dated much later, to the end of the twelfth or even the start of the thirteenth century.

All of the interior walls of the small hall church with three apses are entirely covered with paintings. In the half cupola of the eastern central apse appears the Virgin enthroned, with a Christ Child of unusually large proportions. She is flanked by angels with globes; beneath them stand the Five Wise and the Five Foolish Virgins, according to the reading of the gospels on St. Catherine's Day.

The apex of the left side apse bears a depiction of the Lamb of God, to whom John the Baptist and John the Evangelist refer. The main image in the right side apse represents the "traditio legis", with Apostles Peter and Paul receiving the insignia of key and book from the enthroned Lord. On the narrow sections of wall between the main and side apses are figures, perhaps representing prophets, or perhaps the donors of the church.

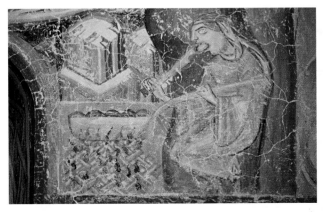

A nun eating a dumpling, c.1200

On the wall above the apses, Christ Pantocrator is enthroned in the center, and at his sides, likewise seated on throne chairs, the Twelve Apostles. These walls and the west wall are adorned with scenes from the life of Jesus, from the Annunciation to the women at the grave bearing salves. It is to this sequence that the detail illustrated, the Annunciation and Visitation of the Virgin, belongs. Like all the other paintings, it reflects the predominant Veneto-Byzantine influence on the High Romanesque style. The muralist who designed the depictions in the apses favored a more monumental idiom than that of the – perhaps younger – painter who composed the narrative scenes on the side walls in a considerably looser and more spontaneous manner.

The pictorial program conformed to liturgical stipulations. This is one of the reasons why it is so interesting for contemporary research, being one of the few still extant examples in which ancient traditions of worship are reflected. The altars fill the entire lower portion of the apses, the side altars are lower than the central one, and alone had a "reliquary grave" therefore reserved for celebrations of the mass. Originally the entire altar space could be sealed off by means of curtains hung from a beam above.

Hocheppan is one of the Alpine triple-apse churches which was influenced by Milan and adhered to a liturgy akin to venerable Gallic rites which is still practiced in the city to this day. A solemn procession to the altar bearing offerings plays an important role. The accompanying hymn goes, "Behold, open is the Temple with the Tabernacle of Witness, and the New Jerusalem descends from Heaven. Therein is the Throne of God and the Lamb. And his servants bring him offerings and speak: Holy, holy, holy, Lord God Almighty ... And behold, in the middle of the Temple on the Throne of his Glory sits the Lamb ..." As the curtain drew aside in Hocheppan, the congregation saw the image of the Lord enthroned, with Heavenly Hosts and Lamb of God. The two side altars received offerings, between them the Eucharist was celebrated.

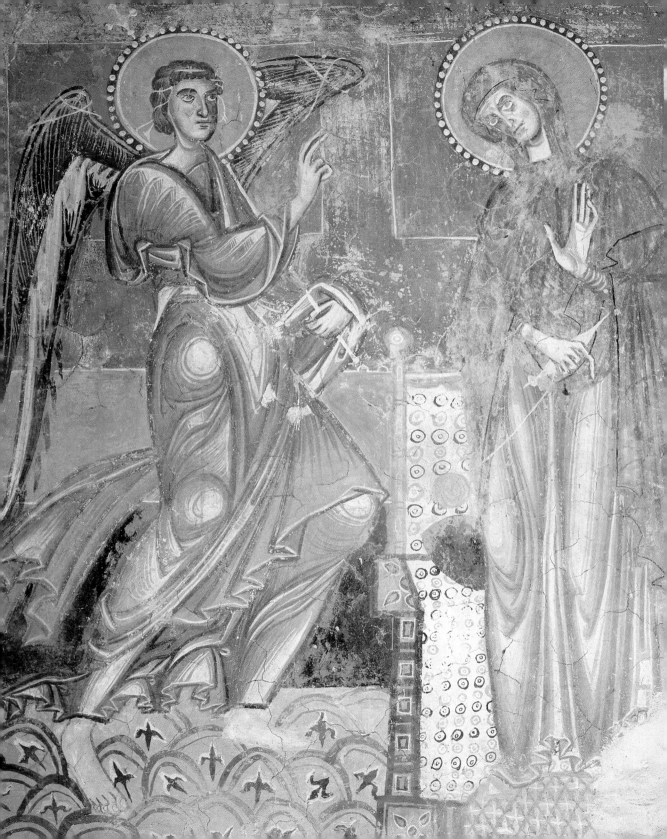

on whales

Tempera on parchment, gold leaf, 27.6 x 18.3 cm
Oxford, Bodleian Library, Ms. Ashmole 1511, folio 86v

English Romanesque art suffered immeasurable losses as a result of subsequent iconclastic excesses. Especially frescoes and panel paintings in ecclesiastical setttings were destroyed by fanatic adherents of John Wycliffe in the fourteenth century, and by Protestant zealots in the sixteenth, nor were sculptures, reliquaries, and many other church accessories spared. Yet in one field Romanesque painting found a saving refuge: between the covers of exquisite illuminated manuscripts.

Towards the end of the twelfth century, a new type of book caused a furor among England's scholarly clerics and laymen alike: the richly illustrated bestiary, a book on animals based both on biblical and late-antique sources in which poetry and truth, legend and natural science, the exotic and the local were combined into a colorful kaleidoscope of creatures. Encyclopedias with a tendency to the sensational, bestiaries met the needs of a public that was thirsty both for knowledge and entertainment.

Among surviving manuscripts of this type, the specimen that came to Oxford University in the late seventeenth century is one of the oldest and doubtless most beautiful picture series. We know neither the artist nor the exact locale in which the book was made. Yet one thing seems certain: it was available to voracious readers in a Cistercian monastery. Leafing through the total of 129 miniatures, the monks, and likely also attendants of the monastery school, must have felt astonishment and awe at their magnificent evocations of the wonders of nature.

The codex, luxuriously adorned with gold leaf and additional passages of silver, contains fabulous depictions of animals, plants, and human figures, executed in brilliant colors deployed in lucid, calm, symmetrical compositions. Ornamentation of the most subtle elegance complements this jewel of manuscript illumination, whose abundance of examples of individual animals and plants is compelling.

On the verso of folio 86 we find the illustration, and below it, the beginning of the caption, on whales. The balena, Latin for whale, is described as a monster of the sea, a gigantic creature with an incredibly massive girth. It was no coincidence that it was just such a creature that swallowed the prophet Jonas, who likened the stomach of the fish, as reported in the Old Testament, to the underworld, to Hell.

The illuminator attempts to do justice to the creature's enormous size by juxtaposing it with a rainbow-colored sailing ship. A viewer today might, however, be more impressed by the exquisite colors of the depiction with its shimmering golden highlights in the background than by the supposed monstrosity of the whale, which is just engorging a few fish. Anyone with an aesthetic eye will admire the decorative mastery with which whale and ship are combined into a composite figure, the body of the many-finned animal rears as if to dive, and the green, swirling waves of the sea provide an ornamental foil for the whole.

Even though this image may be by far the most beautiful in the bestiary, the book as a whole, this event in Romanesque art, reflects page by page the compositional, coloristic, and decorative mastery of its illuminators. Suffice it to compare the three-part miniature on folio 10v, On the Nature of the Lion.

**On the Nature of the Lion,
folio 10v**

officium habeant. Amphi enim grece. utrunq; dr. i.
qp maquis i mtris uiuiunt. ut foce. cocodrilli ypota
mu. h. est equi fluctuales. De balena.

St belua inmari q̄ grece aspido delone dr. latine ū
aspido testudo. Cete i dicta. ob immanitatem cor
pore. ē. enim sic ille qui excepit ionam. cuius aluus
tante magnitudinis fuit ut putaret̄ infernus cum en

тhe sleeping ᴊesse

Section of the Hildesheim Decorated Ceiling, probably tempera (with small amounts of oil) on primed oak boards, overall length of ceiling 27.6 m, width 8.7 m, total area approx. 240 sq.m., containing a total of 90 fields
Hildesheim, former Benedictine monastery church of St. Michael's, ceiling over main nave

The monumental paintings on this ceiling, composed of 1,300 oak boards (see also ill. 25), are among the major achievements in the field of Romanesque panel painting that have survived north of the Alps – artistically far superior to the panels of the Graubünden (Grison) ceiling in Zillis (ill. p. 24). This became even more apparent after the most recent restoration, completed in 1960, which revealed large areas of the original coloration with its brilliant lapis lazuli blue and luminous vermilion red when later paint layers were removed.

The motif of the Roots of Jesse, which emerged in the twelfth century and was first depicted on a large scale in the stained windows of Saint-Denis and Chartres Cathedrals, took on a unique effect in the ceiling painting in St. Michael's. The sequence draws the viewer into a vision of redemption that extends from the Tree of Knowledge and the Fall from Grace to the Tree of Life of Christ.

The story told in the ceiling painting, orientated along the nave axis, begins at the west end – the crypt under the west choir harboring the grave of the church's founder, Bishop Bernward, canonized in 1192/93 – and extends along the central nave, the main gathering place of the lay congregation. The church's saint is honored and integrated in the painting's symbolism as the ancestor of future ecclesiastical leaders.

After the picture of the Fall from Grace, that of Jesse sleeping and dreaming in his elaborate bed forms the true introduction to the family tree leading to the Messiah, which unfolds in the square principal tableau.

In terms of composition, the division of the ceiling into fields seems to have depended on the disposition of the stained glass of the period, with its vertical and horizontal sequences defined by leading. Stylistically, in contrast, links can be found with the "Wolfenbüttel Pattern Book" (Wolfenbüttel, Herzog August Bibliothek, Cod. Guelf. 61.2 Aug 4°), which in turn was shaped by Byzantine models in Venice. Additional analogies with the illustrations in the nearly contemporaneous "Sedlec Antiphonary" (Prague, National Library, Ms. XIII A 69) suggest further interesting connections. Apparently there were illuminators in the region who brought patterns from the east, from Byzantium and the crusader states of the Holy Land, to northern Germany.

At any rate, all of the art works named, including the Hildesheim Ceiling, represent the so-called zigzag style with its abruptly broken, unorganically harsh drapery folds and splintery layering of planes throughout. Investigators have debated highly controversially about the emergence and development of this idiom, basically agreeing only on the prominent role played in it by Byzantium. For a long time, furthermore, this extreme style was thought to have been "invented" on the basis of such influences around 1210 by manuscript illuminators in Thuringia and Saxony. In the meantime, art historians have come to stress its affinities with the "expressive" style of eleventh-century English book illumination. On the other hand, they again point to the innovations of Venetian artists schooled on tenth-century Byzantine works, artists of the kind who were active in San Marco and the Florence Baptistry.

Whatever the case, the popularity in Saxony of this style intermediate between the Romanesque and early Gothic cannot be gainsaid. This is underscored not least by the somewhat later paintings in Brunswick Cathedral, which are quite closely related to the Hildesheim Ceiling.

NORINT HOC OMNES QUOD GALLICUS ISTA JOHANNES PINXIT EUM CALVUM DEUS UT DET VIVERE SALVUM

The inscription of "John of Gaul", who, already bald headed, petitions God to give him eternal life, is to be found on one of the central nave columns of Brunswick Cathedral. An artist who took part in one of the greatest mural programs of the German middle ages, has immortalized himself here.

To stay informed about upcoming TASCHEN titles, please request our magazine at www.taschen.com/magazine or write to TASCHEN America, 6671 Sunset Boulevard, Suite 1508, USA-Los Angeles, CA 90028, contact-us@taschen.com, Fax: +1-323-463.4442. We will be happy to send you a free copy of our magazine which is filled with information about all of our books.

© 2007 TASCHEN GmbH
Hohenzollernring 53, D–50672 Köln
www.taschen.com

Project management: Ute Kieseyer, Cologne
Editing: Jürgen Schönwälder · Büro für Kunstpublikationen, Munich
Translation: John William Gabriel, Worpswede
Composition: text & typo, Anja Dengler, Munich
Production: Tina Ciborowius, Cologne
Design: Sense/Net, Andy Disl and Birgit Reber, Cologne

Printed in Germany
ISBN: 978-3-8228-5446-4